JACQUELINE
DONACHIE
RIGHT
HERE
AMONG
THEM

JACQUELINE DONACHIE

RIGHT HERE AMONG THEM

CONTENTS

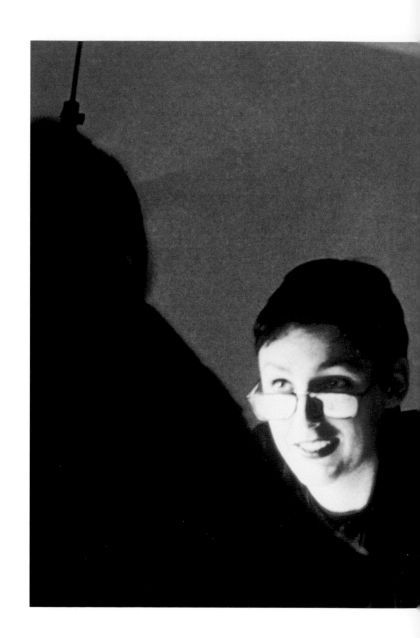

The exhibition by Jacqueline Donachie that this book accompanies is the winner of the inaugural Freelands Award, established to support an institution outside London in working with a mid-career female artist to realise a substantial exhibition with a focus on new work. The Award was set up in response to a report, commissioned by the Foundation in 2015, which discovered that although female art and design graduates outnumber men, women

PREFACE

we are delighted that it has enabled Jacqueline Donachie and The Fruitmarket Gallery in Edinburgh to work together on both a major exhibition of new work and this handsome publication.

In selecting this project for the Award the judges were struck by the Fruitmarket's track record in working closely with artists, helping them to take the creative risks necessary to develop their practice and present their work to an audience. The judges appreciated the Fruitmarket's commitment to developing diverse audiences for the visual arts, finding new ways to reach audiences with art and ensuring that art engages with people where they are and with life as it is lived.

Donachie's practice does all of that and more. The art she makes is socially engaged, collaborative, generous and imaginative. The Freelands Foundation is delighted to support her in the development of her exhibition at the Fruitmarket, and the legacy for that exhibition that this book provides.

are not adequately represented at, or beyond, mid-career point.

The Award reflects the Foundation's mission to support artists and cultural institutions, and

Elisabeth Murdoch, Founder and Chairman of Board of Trustees, Freelands Foundation

An Era of Small Pleasures, 2017
Leather, brass rivets, 6000 x 8 x 2.5cm

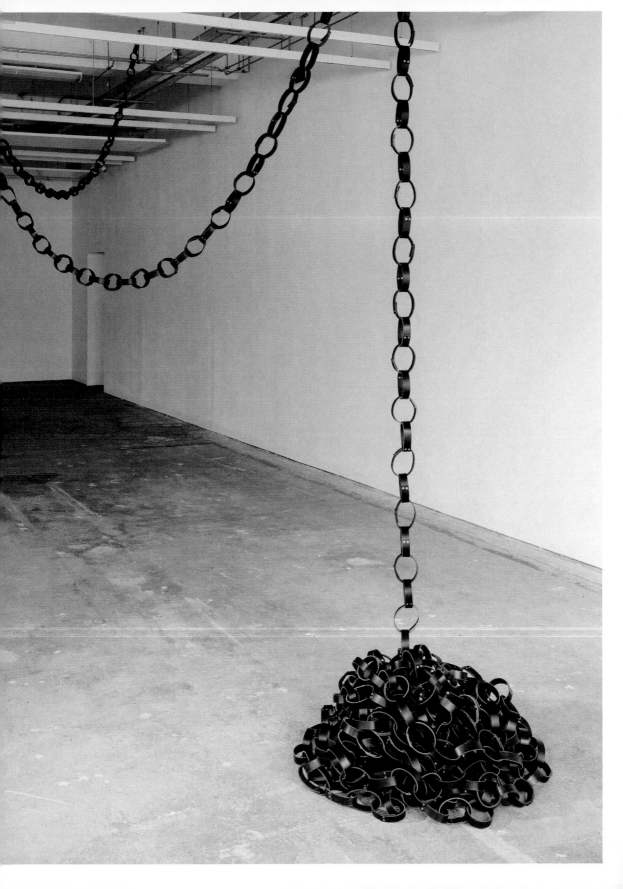

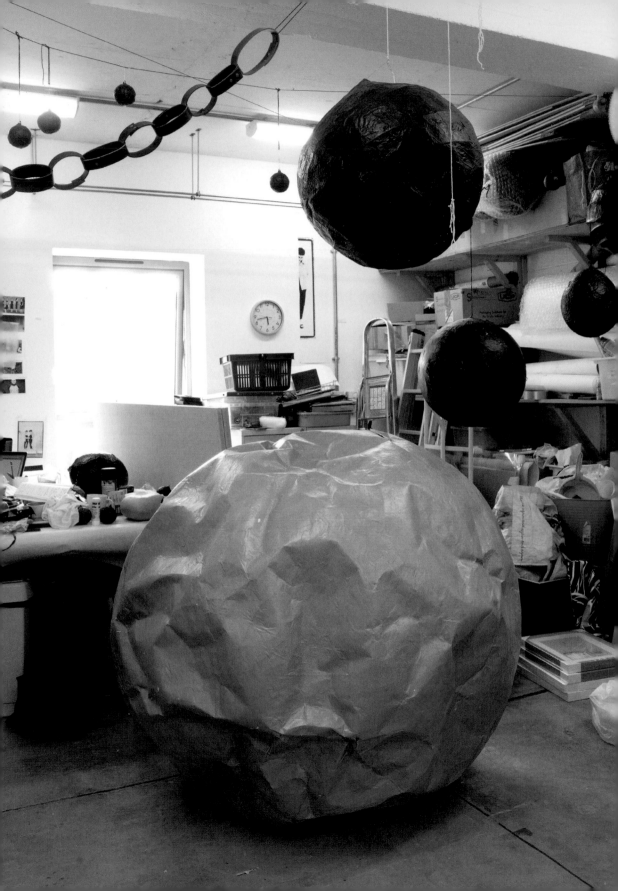

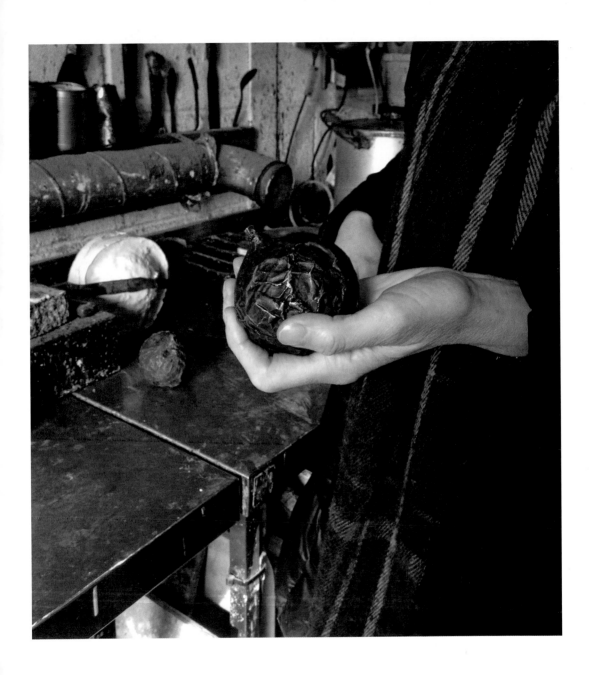

opposite and above: new work in development
in the studio, Glasgow and foundry, Lumsden, 2017

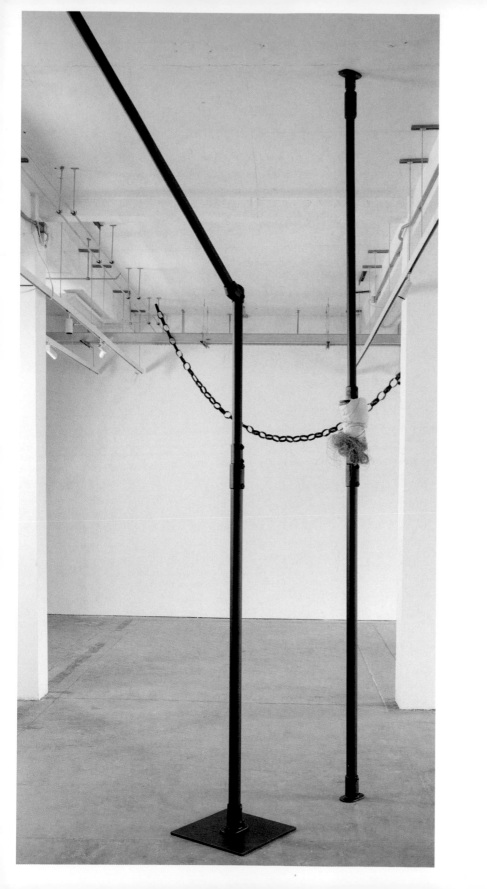

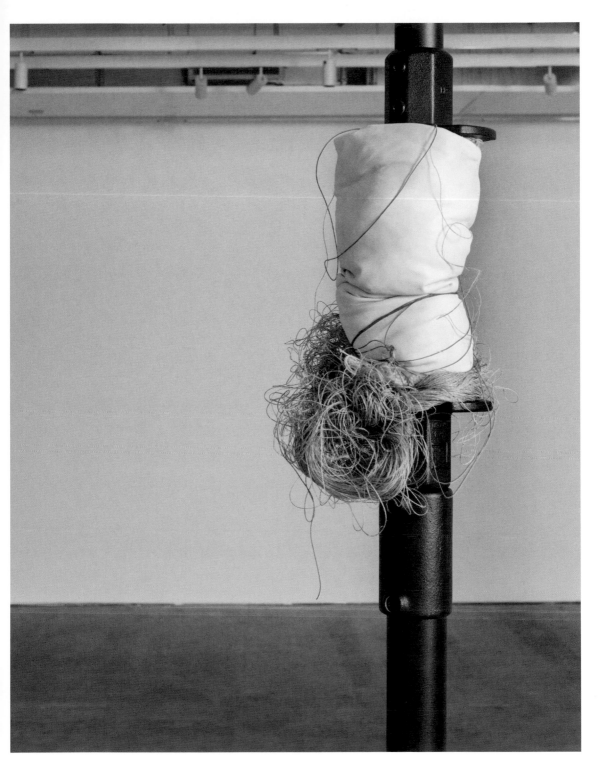

Winter Trees VI, 2017
Powder-coated aluminium, leather, fabric, thread, dimensions variable
following: *An Era of Small Pleasures*, 2017
Leather, brass rivets, 6000 x 8 x 2.5cm

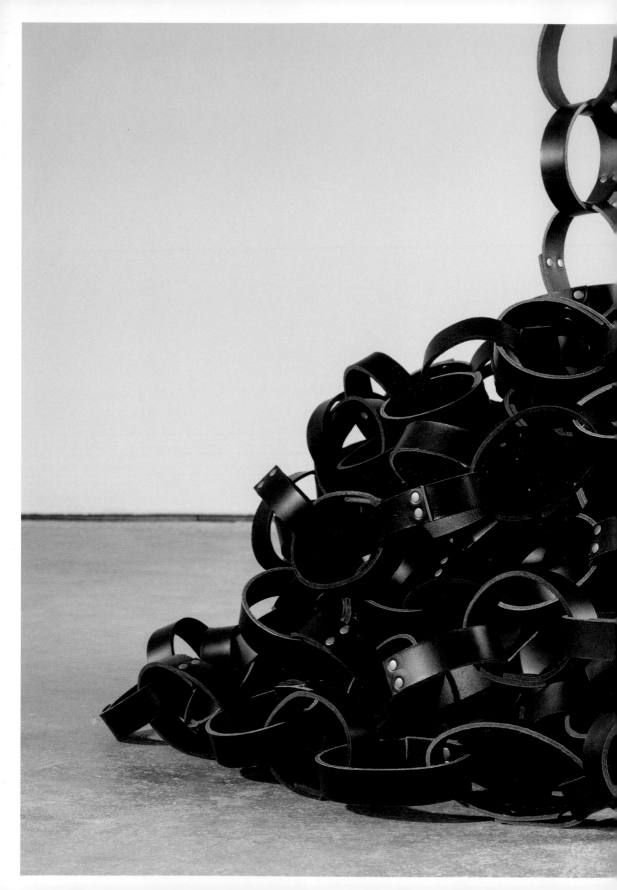

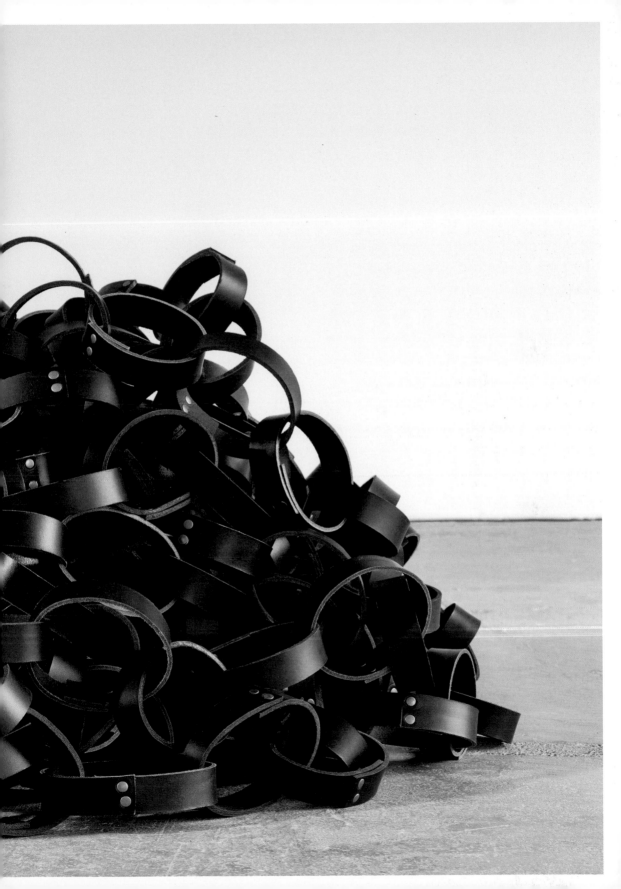

JACQUELINE DONACHIE: AN INTRODUCTION
FIONA BRADLEY

Jacqueline Donachie's practice is rooted in an exploration of individual, family and collective identity and the events, structures, platforms and spaces through which it may be constructed and supported. Her work is generous, inclusive and beguiling, and is involved with process and material on the one hand, and with research, collaboration and participation on the other.

Constructing an identity involves finding a place for yourself in the world, working out who and where you are or want to be and how best to communicate that. To make her work, Donachie enlists many of the tropes and strategies through which we do this, making sculpture, installations, photographs, films, drawings and performance that tell stories, make portraits, throw parties, host gatherings, forge paths, go on journeys, keep diaries, playlists, scrapbooks, photo albums.

Much of Donachie's work is concerned with portraiture, and some of that begins with self-portraiture. In the 1990s, she started making *Advice Bars* (pp.32–37). Makeshift in aesthetic, each bar took the form of a table raised to the height of a bar on piles of whatever newspaper was most easily available. A cardboard sign identified the table as a bar, and Donachie offered drinks,

Dressed for the part, glasses on, when working the bar at a busy art world gathering she got to try out different versions of who she might want to be, setting her own rules for whom she would serve and when.

The bars, as Juliana Engberg has noted in her essay in this book, may be understood in terms of relational aesthetics, that kind of art-making popular in the 1990s that Nicolas Bourriaud defined as 'a set of artistic practices which take as their theoretical and practical point of departure the whole of human relations and their social context, rather than an independent and private space' and in which artists are facilitators as much as makers. They also speak of a commitment to hospitality that Donachie identifies as intrinsic to working-class Glasgow, a key part of her upbringing and one of the main drivers of her adult life. When people come round, you make time for them, make drinks and food for them, make a bit of an effort.

but took no money: the only way to get served was to share a problem with her along with a drink. The works were performances and also exercises in self-portraiture, reflective of many years of waitressing and a new job temping for an analyst in New York. Donachie made the bars in cities in which she was unknown, and adopted a persona for the occasion.

There is a strong strand in Donachie's practice that has to do with hospitality, hosting, and making time for people. In 1996, in New York on a Fulbright scholarship and offered an exhibition with Marian Goodman Gallery, Donachie used the opportunity to cook a meal for collectors. The event was the third in a series of dinners that Donachie hosted, recorded and exhibited as sound pieces – the plan for the one for curators (the series included events for artists, curators and collectors) is exhibited on p.20 of this book. As Donachie's practice has developed, her hosting has become more ambitious. In 2003, she organised a mass walk through the grounds of Compton Verney (pp.120-25), bringing together members of groups that reflected the broad and colourful interests of Greville Verney, the last inhabitant of the stately home that now houses Compton Verney art gallery. A staunch unionist, Verney's other interests included, in Donachie's words, 'hunting, shooting, brewing, rights for women, amateur dramatics and eugenics'. Donachie researched groups in the locale that might respond to Verney's passions, and found a republican pipe band, members of Greenpeace, the Campaign for Real Ale, anti-hunt protestors, battle re-enacters and the local hunt. All were invited to join in the walk. The event was fun and celebratory but also (like family parties) not without the tensions of clashing ideologies.

This element of Donachie's practice probably finds its most complex expression in the three *Slow Downs* she has made in the northern Scottish town of Huntly, the city of Glasgow, and Melbourne in Australia. These works made both time and space for people, imagining what our urban spaces might be like if car use was challenged, better bike lanes installed and people were encouraged to use bicycles more visibly. Each culminated in a giant cycle ride and celebratory gathering, with drinks, food and chat. As people rode in groups from the outskirts of the city to the centre, chalk dispensers attached to their bikes marked out their routes in coloured chalk, each rider's trace coming together to make a long, communal drawing, a ribbon of multi-coloured chalk.

These event-based artworks bring people out and together, encouraging them to identify themselves to themselves and to other people as artists, campaigners, passionate hobbyists, cyclists, drinkers, eccentrics, people who care about the environment and/or their own wellbeing. And Donachie orchestrates the events, and the participants' individual and collective contributions, with an eye to aesthetics as well as enjoyment. The chalk

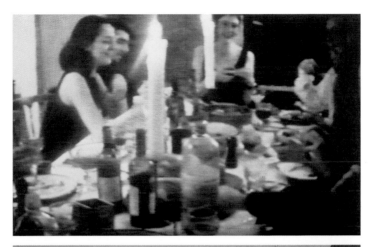

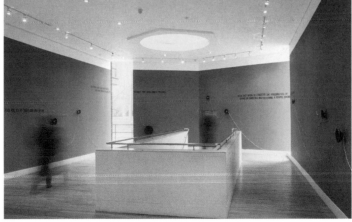

Thirteen Stories (Curators), 1995
Installation with soundtrack, one of three dinner parties with Artists, Collectors, Curators

dinner - thirteen stories.
Friday 13th January - 'Little Hill', much Hadham,
 Herts.

claire 2 curries? or Haddock + Pasta?

· clare · lentil curry Mafia type,
 red table cloths
· mel - lentils bowls of pasta
 coriander (fresh) + meatballs?
· mitsuru
 · tomatoes
· matthew · tom. purée 'some day you may have
 onions to cook for a lot people'
· maurits the Godfather
 (to Al pacino)
· olabisi
· kitty rice/naan bread smoked Haddock,
 cream
· marcelo broccoli
· andrea
· kurt Potato curry? Salad
· gavin potatoes
· nigel (14) cauliflower/broccoli Fruit salad
 onions
+ me garlic, mushrooms cheese + port
 creamed coconut
 single cream
 natural yogurt Cocktails first £ £ -
 curry paste
 Long Island Iced teas
 Tom Collins —
 got veg/& cream from Tesco vodka Martinis?
table not square indian stuff would
 be a problem.
 Like
 fresh lemons
 vodka Gin,
 Gin soda water
 white rum lemons/limes
 caster sugar
 + olives.

drawings made during the *Slow Downs* are (at least until it rains) carefully constructed and beautiful public artworks, their coloured lines running down slopes under brutalist concrete flyovers (pp.220–21); meandering round lamp posts (p.210); and defiantly occupying the middle of car-free streets (p.160). Throughout her events, Donachie stages and records resonant moments – herself leading the bicycle charge through Huntly (p.160); a young band leader keeping everyone in step as they stream across the fields of Compton Verney (pp.122-23); the sounds of a dinner party displayed later as disembodied audio (p.19).

Sound – music in particular – is an important medium for Donachie; she makes effective use of its power to create mood, construct narrative and establish identity. Music is democratic, and most of us can put together playlists of our lives, using music to trigger memories and recall experiences. For her first major public exhibition in Glasgow's Tramway, Donachie fixed hundreds of paper cone speakers of varying sizes to the walls, and put nothing else in the space (pp.27, 30–31). Drawn towards the speakers, visitors to the exhibition became embroiled in a 45-minute aural narrative, Donachie whispering in their ears, playing them music and snippets of sound. Described by artist Douglas Gordon at the time as

'a soundtrack to a film that doesn't exist', the work encouraged viewers to match their own experiences, memories and personal histories to Donachie's. Gordon again: 'I wandered into the space late on a wet Saturday afternoon, just as Elvis was finishing up *Lovin' You*. I heard the sound of a key opening a door which led into darkness as a car drove off from the night before and into the morning after. As I was trying to make sense of what was happening I hardly even noticed the Sex Pistols creep up on me. But there they were and here was I back at school with my first laced up boots and corduroys, waiting for that first kiss along with all the other pretend-punks in too-tight Adidas T-shirts, claiming to hate the Human League because they were not as cool as Sham 69 or whatever. Or, at least, this is how I think I remember things'.

These works make time for people. They also make space. Donachie's works often make spaces and places as well as time. Two works from 1999 come to mind: *Holy Ghost* (p.57, 58–59), a pavilion made for *In the Midst of Things* in Bournville, Birmingham, and *The Disc* (pp.65–71), a platform for a housing estate in Darnley, Glasgow. In both cases, Donachie made a space in which you could both experience and imagine things happening. Each work was launched with a performance

that took its cue from the current use of the site and its surroundings. *Holy Ghost*, sited on a village green in a Quaker-established conservation village, was inaugurated by a loud and passionate gospel choir from nearby Birmingham singing *Amazing Grace*. Donachie has commented: 'I wanted to challenge the prim silence of Bourneville with something raucous. I wanted the choir to be almost shouting at God'. *The Disc*, high on a hillside overlooking a motorway and a 1960s housing estate, forced romance on a mixed crowd of locals, artists and council officials by inviting them to dance.

Typical of Donachie's practice in many ways, these two projects combine participation, process and research with tangible objects and events in which the artist suggests a possible use for the space she has created before backing away to allow audiences to use it how they will. A visitor to Donachie's work is often invited to bring ideas with them as well as take some away. *The Disc* was one result of a six-month residency in a housing estate on the southern outskirts of Glasgow that was being redeveloped at the time. Donachie brought to her observations of how people moved round the estate – what worked for them and what didn't – her interest in moments when the rules of public space change, when people overpower

architecture and urban planning. She speaks of noticing a roundabout on the route to Celtic Park football ground. On match days, when pedestrians stream towards the ground, it ceases to be a roundabout, and becomes instead a meeting point and lookout post, people congregating on it to seek and find each other. *The Disc* seeks to capture some of the anarchic joy of this, Donachie making a round, elevated platform for games, dances, picnics, or whatever people want, isolated high above the housing estate. Her own idea for how to use it – the sunset waltz that gave rise to one of the most visually arresting images in her work (p.99) – is only one possibility.

The Disc is about changing the rules, making a difference, empowering people to take control of their environment. It tries to include people and it has quite a back story in the artist's reflection on the public space that had been sacrificed in the development of the new housing. Typically, in her attempt to make a memorial to that public space, she creates a new space in which people, not planners, get to decide what happens. Research and collaboration are important tools in Donachie's quest to help us understand ourselves and our place in the world, and she has worked with a variety of 'expert cultures' from topless dancers, visually impaired judo students and highland

dancers to medical professionals, scientists and academics to find material for her art.

This has continued as she has focused much of her work in the past decade on the social and scientific contexts of illness, disability and difference, working with scientists, researchers and individuals whose lives have been affected by specific genetic conditions. The impulse for this was personal: in 1999, her sister's second child was diagnosed at birth with myotonic dystrophy, a genetic condition with a distinct inheritance pattern (mild, late-onset symptoms in the grandparental generation, more severe symptoms in the parental, profoundly disabling symptoms in the child). Very close to her sister, similar to her in looks and pregnant herself at the time, Donachie discovered that she had not been passed the gene, and that she and her subsequent three children were unaffected by the condition, while her sister, brother and other members of her wider family were variously and progressively affected.

Donachie's response to the sudden medical revelations, and the subsequent alteration of her family's and her own sense of identity, was to use art as a means to find out more. Collaborating with a range of medical and scientific research professionals and with a number of affected families, she made, together with Darren G. Monckton, Professor of Human Genetics at the University of Glasgow, *Tomorrow Belongs to Me*, a project culminating in a film, book and exhibition for the Hunterian Museum, Glasgow in 2006; and *Deep In the Heart of Your Brain*, an exhibition for the Gallery of Modern Art, Glasgow in 2016, which brought together sculpture, drawings and film informed by the material she has gathered and relationships she has made during the course of her research into myotonic dystrophy.

Naturally, much of this work focuses on Donachie's relationship with her sister. She had previously made art about the two of them, or more exactly about how her resemblance to her sister has shaped her sense of self: 'All my life I've been told how much I look like my sister. Are you twins? Which is which, I can never tell. We never saw it. I was younger and for most of the time rounder (I burst her leather skirt in 1986 and she never let me forget it …). And she's a few centimetres shorter than me, which for tall girls in the inherently stocky West of Scotland is a big deal'. The work on the cover of this book is a hugely enlarged snapshot of Donachie's studio wall taken some twenty years ago. The wall is dominated by images of the identically dressed sisters posing together, a theme taken up again in *Pose Work for Sisters* (2016, p.239), a video work where difference,

as well as similarity, is the dominant theme; and in the final seconds of the film *Hazel* (2015, pp.246–47) in which Donachie and her sister, again similarly dressed, walk together away from the camera.

It also infuses some of Donachie's recent drawing and object-making, in particular *Glimmer*, her ongoing series of drawings of tall, slender urban objects – street lamps, CCTV cameras on poles – (pp.199, 202–03, 254) and *Winter Trees* – tall, crane-like (both the bird and the machine) structures typically made in pairs, one stooping, one not (pp.12, 140–41). Again, there might be quite a back story to these drawings and objects, but they do not really need it. Encountering one of the *Winter Trees* you can't not see yourself in relation to it, measure yourself against it, allow it to tell you something about who you are and who you're not.

Donachie makes art that enlists the help of the world outside – people, places, things – to help tell stories of ourselves in the world back to us. An installation image of the first showing of *Winter Trees*, in Gothenburg Art Museum, shows the handrail for the museum's stairs cutting across the display of Donachie's framed drawings on the wall behind. The drawings are of things like the handrail, structures we may need to help us get around. The handrail

itself looks like the *Winter Trees*, and others of Donachie's objects – *Three Pinkston Drive* (2002, pp.106–07), *Dear Wives* (2002, pp.108–111), *Speedwork* (2010, pp.184-91), *Nice Style* (2016, pp.248–49) – that use scaffolding poles to construct sculptures that are both lines in space and the kind of improvised grab rails that people who need them search for and find in the street, park and garden furniture round about. Donachie's scaffolding sculptures have an ungainly grace that draws our attention to how they occupy and navigate space. Much of their affect is, for me, focused on the joints which support and occasionally fail them. A simple scaffolding joint (in the online catalogues I looked at they are called couplers) can speak volumes, especially when paired with another, with a safety net, or with a jointed armoured leg (p.259).

Objects are currently proliferating in Donachie's work. They have always been there of course – even the *Advice Bars* are objects first and last, the animating performances only temporary, the bars themselves Minimalist sculptures in a gallery space. *New Weather Coming* (2014, pp.228–35) placed three arresting if somewhat inexplicable (or perhaps arresting *because* inexplicable) metal objects at transport interchanges around Scotland to articulate Donachie's thoughts about how journeys shape

families. Built on trailers, made from the kind of non-slip textured metal that safety and access ramps are made of and painted bright green, the sculptures interrupted people's journeys, making a place to pause, to get your breath back as you contemplated what you had to do next in order to get where you wanted to go. *Deep In The Heart of Your Brain is a Lever* (2014, pp.222–-23, 225, 250–51) speaks a similar sculptural language. Its black metal nastiness and ramp too steep to negotiate focus (among other things) Donachie's sense of helplessness in the face of the withdrawal of services designed to make life easier for people who need support. It was made in and for an art gallery housed in a former therapeutic swimming pool and speaks primarily of loss – 'a substantial dark object, a black hole one could say'. These objects operate primarily as sculpture, exerting a physical and material force in space. In many ways, though, they are tips of icebergs; the only visible manifestations of a much larger mass of thought, research, writing, collaboration, and ideas lurking below the surface.

As I write, new objects are taking shape in the studio. Drawing lines and finding paths in her head through space and through the history of her own work, Donachie is making things including a new scaffolding line; a new metal structure that may or may not be a space for sitting; metres of leather paper chain that can loop and pool; two bleakly black new *Winter Trees* and a series of balls of similar and different size and weight. Many of the themes familiar in her practice collect in this new work and in how it is made, and it will find its final form as it encounters an audience.

Donachie's objects have a material generosity and curiosity that sparks our own. Getting on an aeroplane last week, my head full of her work, I noticed for perhaps the first time the textured metal of the steps and the rather alarming flimsiness of the handrail. As much as Donachie's art can provide a context in which to think through specific ideas, it also works a subtler magic; encouraging a visitor to enjoy occupying the same space as it, to think with and alongside it, it expands out of the context in and for which it was made. In doing this, it affects our understanding of ourselves, the relationships we make, and where and how we live.

PART EDIT 1994

Maybe it's the whole lie side of it that's
interesting. There's no particular motive
behind it - I'm not that obsessive. Sometimes
something just sticks in my mind after a
party, or a night in the pub or something.
So I write it down. I think it's my
identification of the stories that makes it
so interesting to me - the title I give each
one. I never really ever write out the whole
story, and I'm sure very often I get the
wrong end of the stick and have a completely
different idea in my head than is actually
the truth, but I guess that's the point. It's
me remembering other people's stories.

Speakers, 45 minute soundtrack of spoken words, music and recorded sounds
Tramway, Glasgow

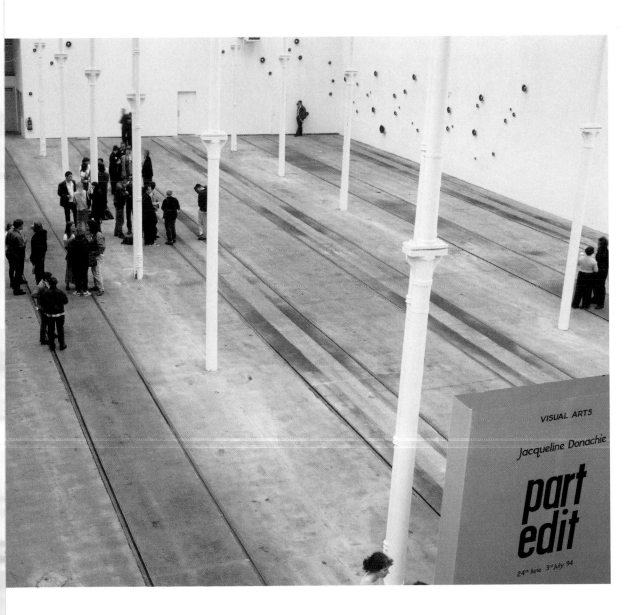

VISUAL ARTS

Jacqueline Donachie

part edit

24ᵗʰ June 3ʳᵈ July 94

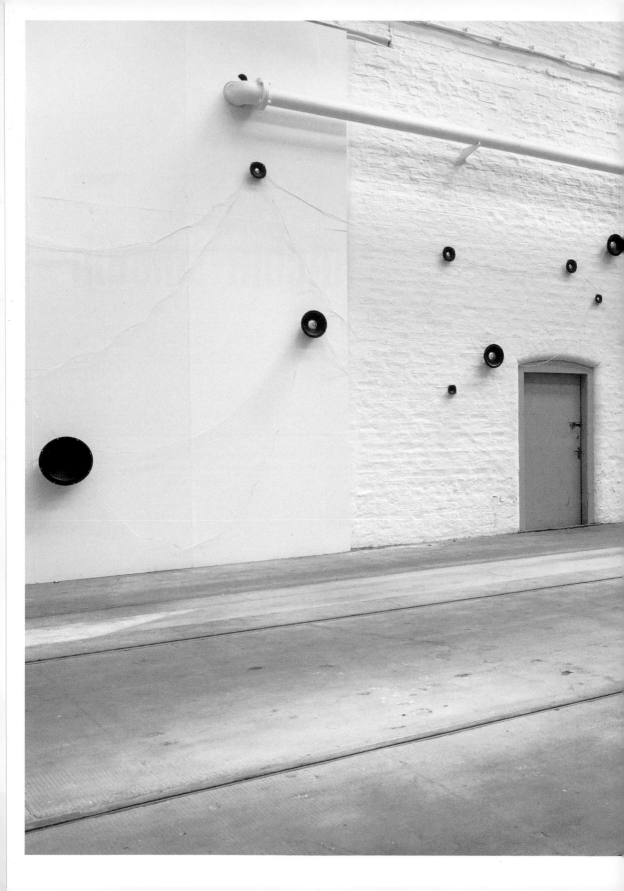

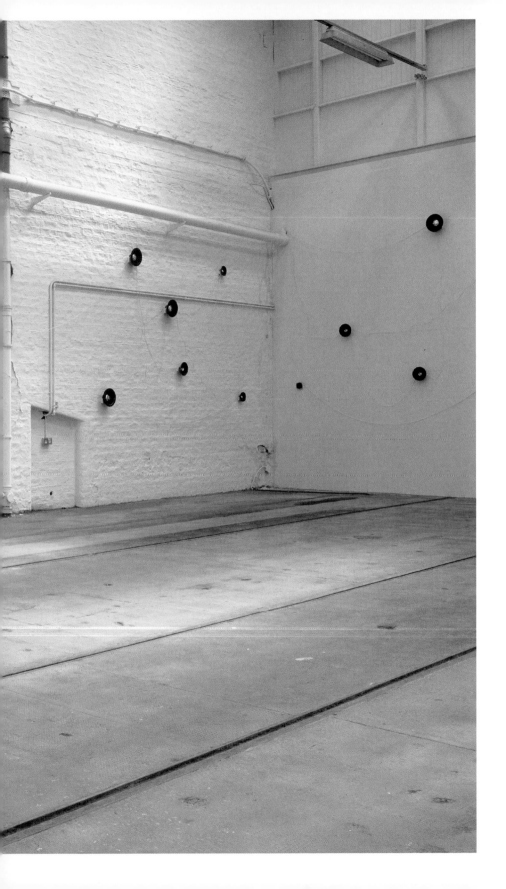

ADVICE BARS 1995–2001

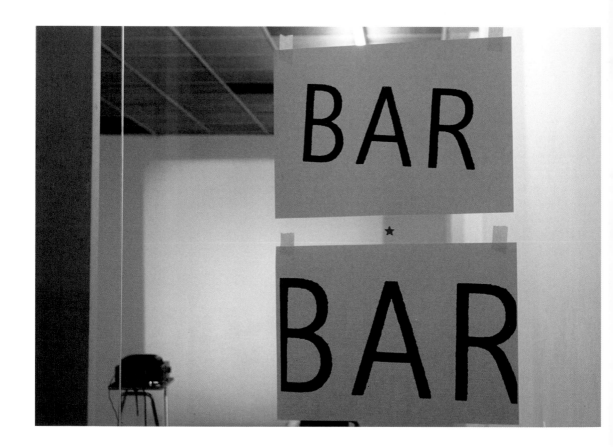

The bars are assembled using trestles and wood, or whatever is available in the space at the time, a cardboard sign and a light. The height of the bar/table is crucial, 1.5m to allow for leaning. For 'Advice Bar', a performance evolved in which drinks were served in return for problems - one problem per drink, one person at a time.

This work initially came about from a lack of people to drink with in New York when I first arrived to study for an MFA, combined with the fact that I worked Wednesdays for an analyst and at weekends in a downtown bar.

Advice Bar Berlin, 1995
Performance and installation: 1.5m raised trestle table, light, suspended handmade cardboard sign, whisky
Galerie Eigen + Art, Berlin

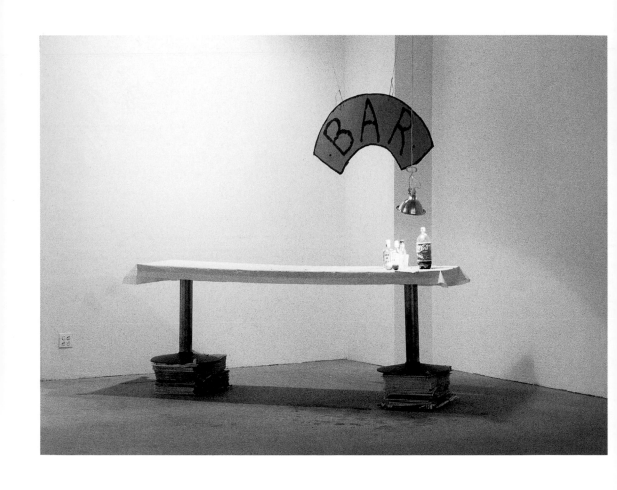

Advice Bar New York, 1995
Performance and installation: 1.5m raised table, newspapers,
light, suspended handmade cardboard sign, Long Island Iced Tea
Hunter College, New York

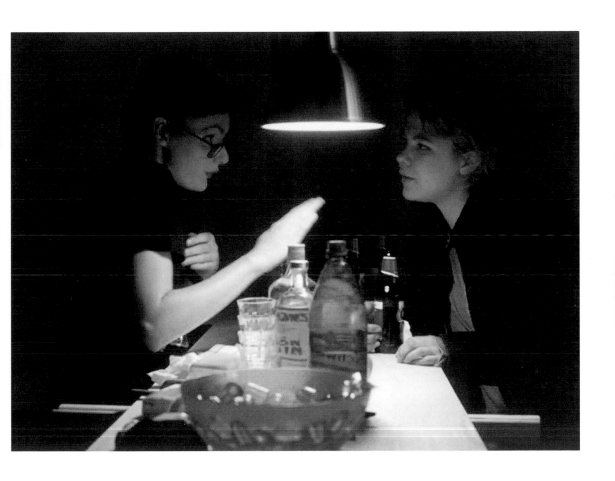

above and following: *Advice Bar Utrecht*, 1997
Performance and installation: 1.5m raised trestle table,
light, suspended handmade plywood sign, gin
Casco, Utrecht

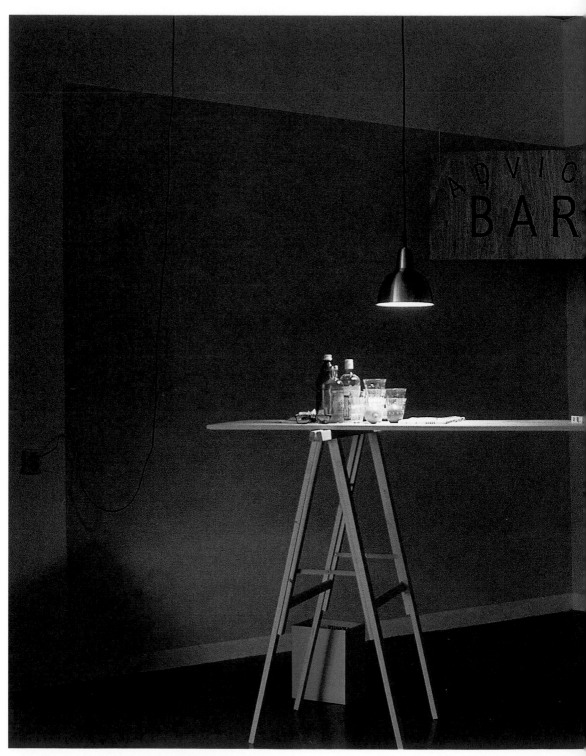

BEER GARDEN,
NEW YORK 1996

Installation: handmade cardboard sign, plastic tables and chairs
Hunter College, New York

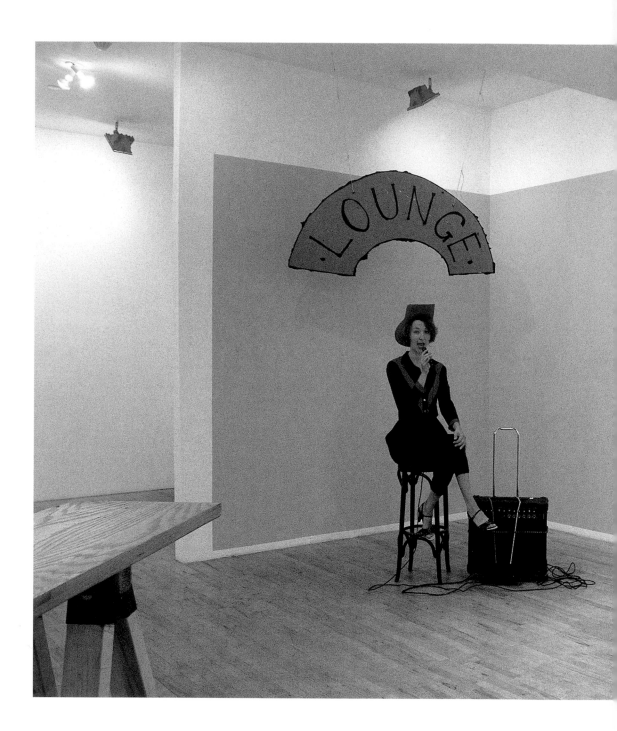

Installation with live event: 1.5m raised trestle table,
handmade cardboard sign, wall text, amplifier, country and western singer
Jack Tilton Gallery, New York

STARS AND
BARS 1996-1997

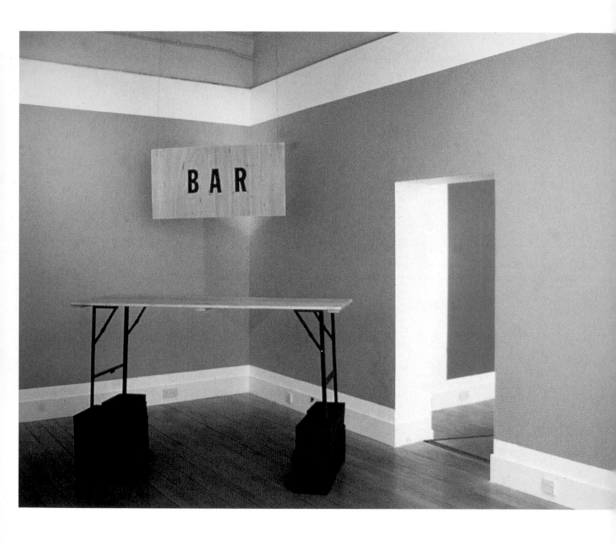

Installation with live event: 1.5m raised trestle table, paper,
handmade plywood sign, wall text, amplifier, country and western singer
Collective Gallery, Edinburgh

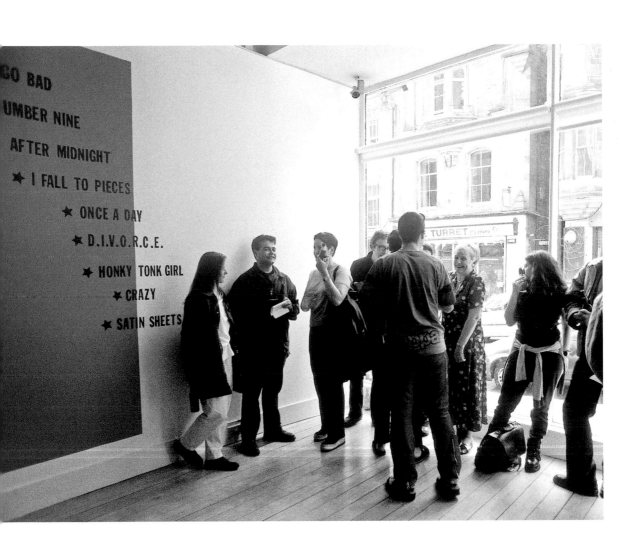

43

LIVE BREAKS 1998

Installation with live event: scaffolding, wood, two monitors, sound equipment
Platform at times populated by dancers from nearby strip clubs
Main stairway, Edinburgh College of Art

3532 MILES 1997

Artist's book. A road trip from New York to New Orleans, via Graceland

DAY 1

WILLIAMSBURG BRIDGE,

JOHNNY CASH

HOLLAND
TUNNEL

You live in a city, and you think it's fairly big. Then you move to a bigger city, and realise yours was actually pretty small. Then one day you decide to leave the bigger city just to see what's out there beyond it. You have a car, and maps and destinations in mind, places you've heard about and always wanted to visit. And a credit card. So you start to drive, and it takes you a long time to get away from the bigger city (which proves how big it really is) and into the rest of the country, but soon you're on open roads under blue skies.

Now in your own city, the smaller one, you can get to any other city pretty much in a day, so you're used to driving somewhere, getting there, doing whatever, then heading back. If you have to stay over, you do it in the place you were aiming to get to. But it doesn't work like that here. You drive till you can't drive any more, then you find somewhere to stay, then you get up and drive again. But you're still going in the same direction, and you haven't got anywhere yet.

Soon your destinations take on a new importance. They become Big Deals. People ask you where you are heading and you tell them and it gives everyone something to talk about other than your accent as they refill

your coffee or your car. They haven't been, but their sister has.

You're beginning to enjoy these one-night-stands in strange places. They are usually small towns, as these are cheaper than the big cities. Or better still, just outside the small towns, on the road that used to be the main road before they built the bigger one. You don't meet Norman though, or his mother.

You become familiar with the ten or so tapes you made up for the trip, and sing along. You begin to know that Orange Juice comes after Nirvana, Glen Campbell after Glen Daly, and that the tape runs out before Ian Dury does. And all the time you're getting closer and closer, and the music and the roads and the motels and the pancakes are all just small things on the way to the big thing.

And then you get there.

Eventually you have to change direction, because the big country has run out and you have only a few days to get back to where you started. But that's OK, because you've seen it all now. You've been.

NO TOWELS

NO KEY)

THE

PLATINUM

TOUR

HEADPHONES ► HOUSE, PLANES, CARS, MUSEUM, FILM.

JOHNNY CASH'S HOUSE

(700 JOHNNY CASH PARKWAY)

THE KING'S HOUSE

(3734 ELVIS PRESLEY BOULEVARD)

HOLY GHOST 1999

The village of Bournville was created by Quakers Richard and George Cadbury
at the end of the nineteenth century to provide housing for the workers in their
nearby factory. *Holy Ghost* was sited adjacent to the Friends Meeting House on the village green,
launched with a performance by The Voice of God, a Birmingham-based gospel choir.
Wood, paint, gospel choir
In the Midst of Things, Bournville, Birmingham

SWORD 1999

Scaffolding, polished wooden beams, sound equipment, 30 minute soundtrack
recorded at Nina Hemingway School of Highland Dancing, Glasgow
The Jerwood Gallery, London

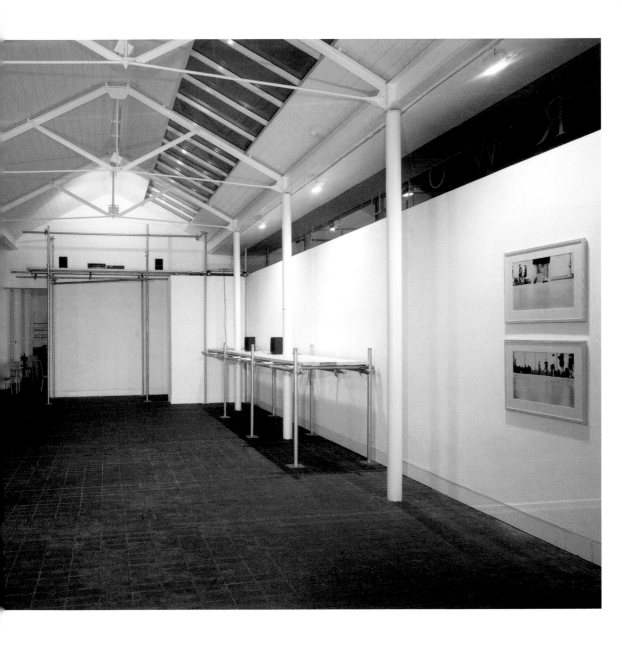

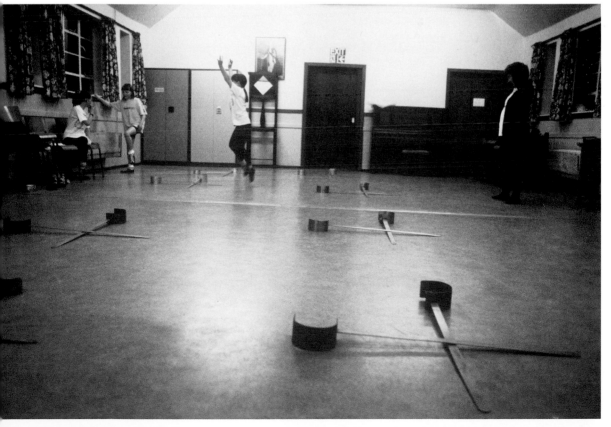

THE TREES, THE BOOK AND THE DISC 1999

When you go somewhere new, in a city where people like
to talk, you tend to hear stories. You don't always
get them straight away, but if you need to rely on
public transport and spend time waiting at bus stops,
or sitting in cafes enjoying a bacon roll, chances are
you'll hear any manner of strange things. Like the
story of the tree with a history way beyond its years,
or the woman on the top floor who cooks all day and is
too large to leave her flat.

Utopian dreams of modernism being demolished as fast as
they were built, seventies inflation putting up loans
faster than homes. Small flats with lots of fresh air
and open space outside. Green grass and rolling hills
surrounded by motorways and dual carriageways with
great big concrete blocks, where people really did try
hard to live with the damp and the state of the art
heating system too expensive to run until eventually
the struggle became too much and something had to be
done.

Then lots and lots of flats being replaced by lots and
lots of houses. Front door, back door, garden fence.
The washing line in the right place this time, which
is important as the last lot got it wrong (they say
that architects don't hang out their washing). Heating

Permanent public work: concrete disc, monkey puzzle trees and artist's book
Commissioned by Visual Art Projects, Glasgow for the Darnley estate

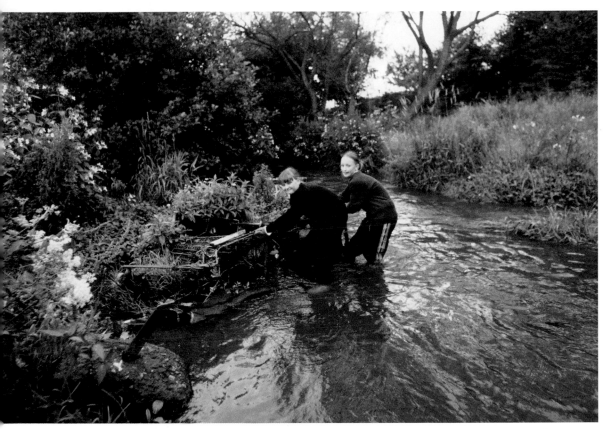

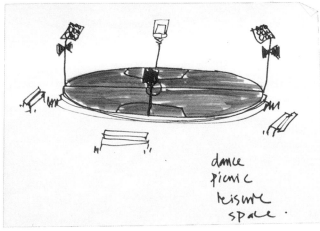

dance
picnic
leisure
space.

Blondes versus Blondes, 1999
Screenprint on Somerset Satin White, edition of 50, 52 x 72cm

that works and strong, solid front doors paid for by less tiles in the bathrooms - security is more valuable than shower space.

Open space disappearing fast. The concrete hippos remain, but the new pitch isn't as good as the one they built houses on and there are no play huts any more. The green rolling hill is still just there, but plans are afoot, and still the burn runs uncleared. But the houses are beautiful and people are proud of them. They've worked hard and waited a long time to be allowed to feel house proud. Frustrating then to have to walk through mud to get to the bus stop. New carpets don't stand up long to dirty, wet feet.

Brand new avenues and cul-de-sacs, the bens and lochs of a nation linked by well trampled muddy footpaths and homemade walkways across the waste ground, and nice concrete paths that abruptly end in nothing (apart from more mud) that must still be there from the last time. And everything built round a centre that used to be there a lot more than it is now.

The polo mint estate.

The price you pay.

Representatives meet regularly and talk about this and other things. Some get annoyed and make objections to everything, all too aware of where their only power lies.

With respect.

Others note and minute the points and hope to be back at the office for lunch. The coffee is good but there are never any biscuits. One group argues, another plans, another just stays away. The elected member questions it all. Parking spaces or houses; six units here, eight there, no that's a swing park and it must stay. Close your eyes and it's a house. No dropping your kids off on the road outside the school any more. Too many cars. The law says they'll have to build a new driveway. Maybe a lassie was killed, maybe it was just a rumour.

Maybe it was just a story I heard.

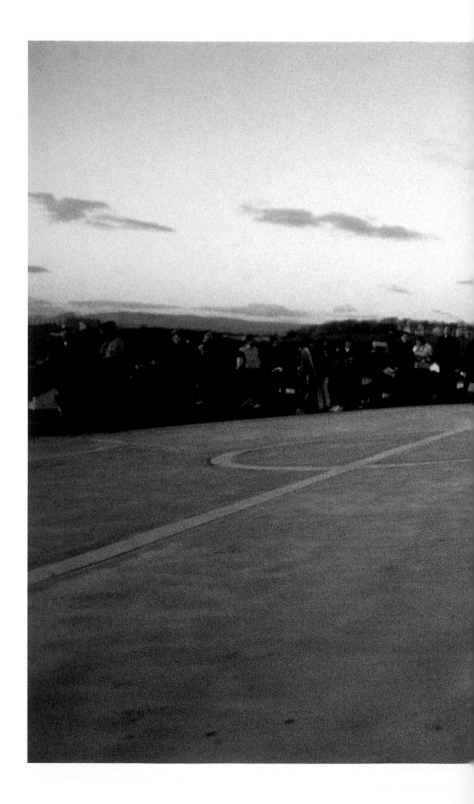

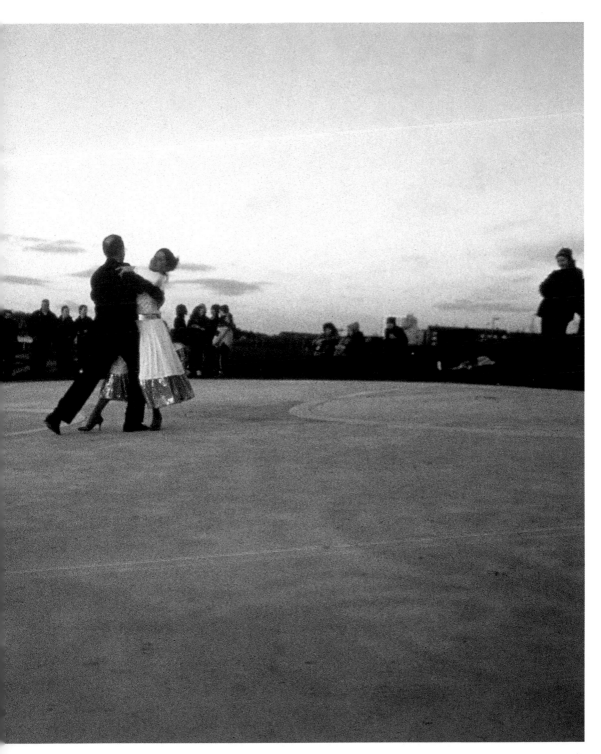

IN THE ARMS OF STRANGERS 2000

There is a fight.

There is a very small, thin lad, about 14, surrounded by tall, heavy, older men. They approach and hold him, then place his hands on their clothing. The boy cannot see. Some of the bigger men can, some cannot. He throws each and every one of them over his shoulder. Time and again, whack, whack, whack.

Each man lands solidly on his back with a groan, then gets up and approaches the lad again.

They keep coming, he keeps throwing.

With every throw he gains more confidence, beginning to enjoy the power of his body. The concentration on his face as each fighter approaches changes to a look of great satisfaction as the man flies over his shoulder and thwacks to the floor.

Eventually everyone is breathing heavily, exhausted by the activity. Their clothes are messed up and they are swearing. The boy stands still as another man shouts, then takes his place in the line to be thrown through the air by another.

PVC, foam, steel bolts, CD player, speakers, 30 minute sound recording
made at Urmston Judo Club visually impaired squad session, Manchester
Leeds City Art Gallery

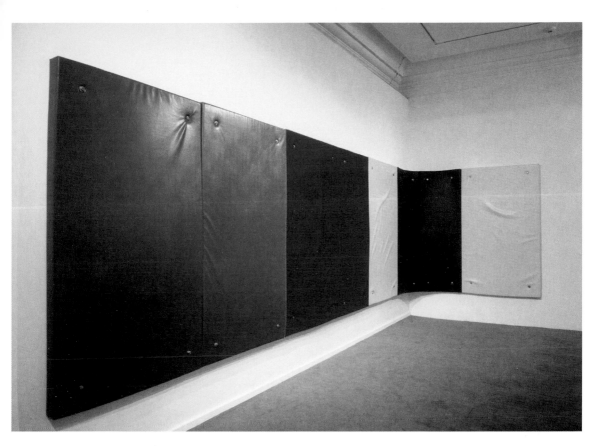

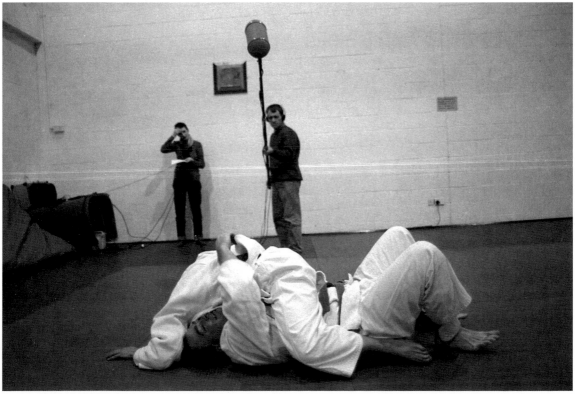

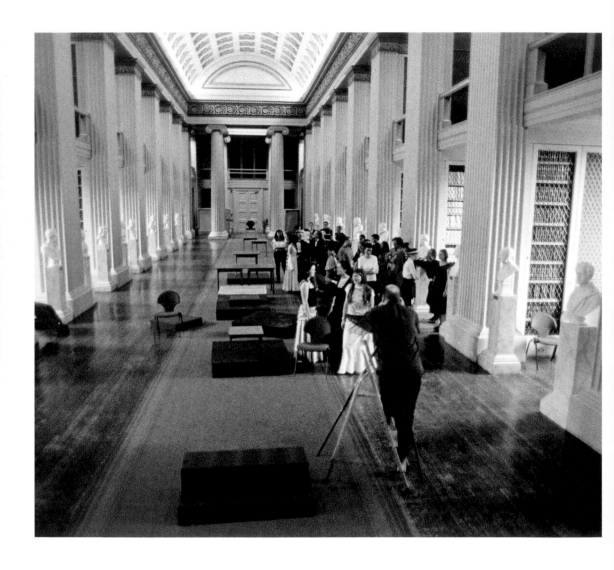

EDINBURGH SOCIETY 2001

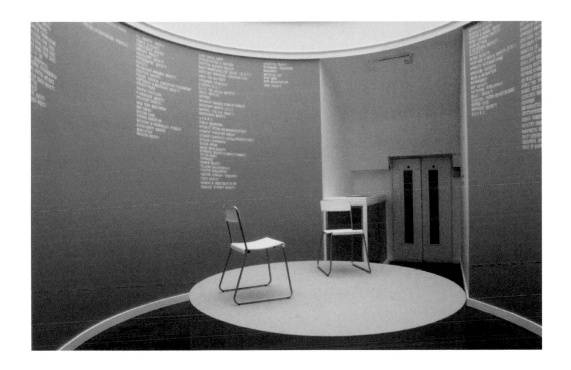

Installation with live events: wooden platform, chairs, painted wall text
Platform at times populated by members of the clubs and societies of the University of Edinburgh
Round Room, Talbot Rice Gallery, Edinburgh

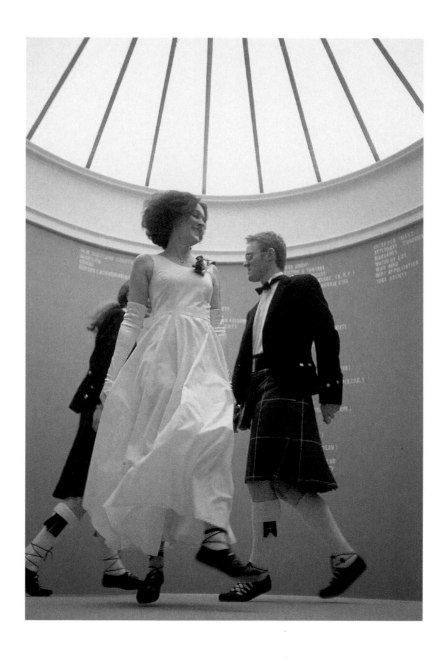

SOUTH 2001

Heated concrete disc, 8m diameter
Spike Island, Bristol

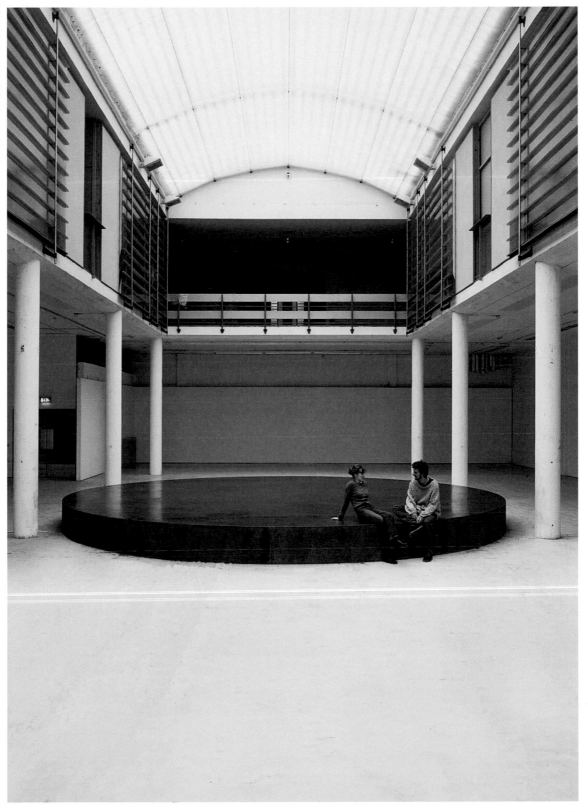

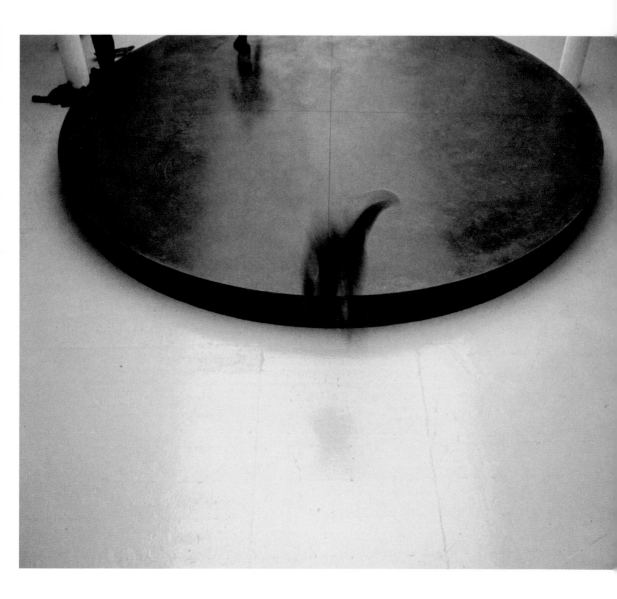

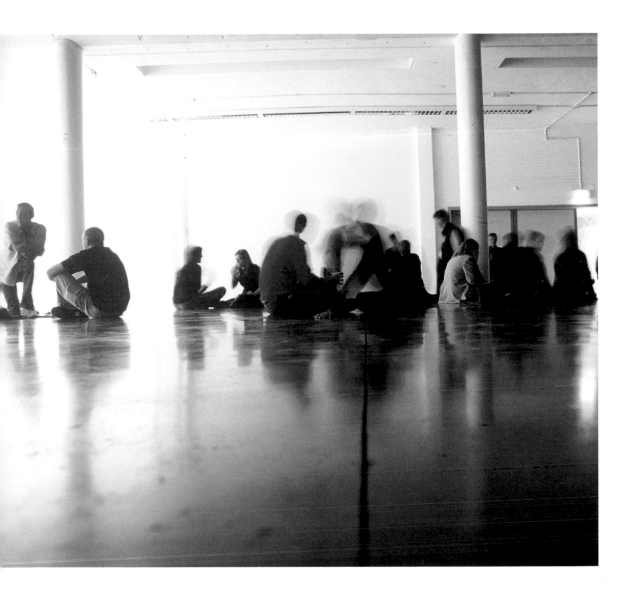

THE HOUSE OF FUN 2001

Wood and aluminium platform/table, wall drawing with acrylic paint,
latex balloons, air and helium, oompah band and poster booklet
HAL, Antwerp

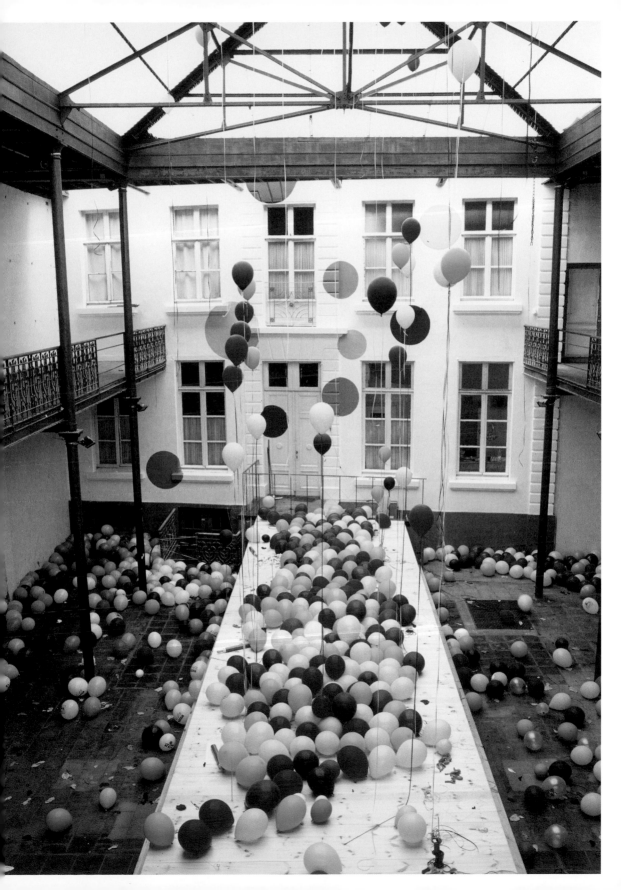

There are three of them. Sisters.

They work from a converted factory in the east of one of the
cities involved. Near the zoo. The factory is the centre of their
operations, run mostly by Clara, the eldest of the three. This is
where the dealers come for their supplies, there is no end to the
demand, and the factory never stops working.

The workers at the factory are too terrified to slow down. There
is never enough for the girls. The work causes them to tire very
quickly. Their lungs grow weak from the constant pressure and they
are always short of breath.

They are exhausted. So exhausted.

Their age doesn't help. The young ones bully relentlessly to keep
them working but they have so little energy in comparison. They are
old and tired. The younger ones do not care, the sisters drive them
all on. They have the most energy. No one knows how they keep going,
they are everywhere, always.

Of the three Anna, the youngest, is the most feared. She is the
troubleshooter, attending to any dealers that get out of hand,
keeping an eye on the streets. Her group terrorise the older ones
in particular, keeping them in line with their constant threats of
violence and damage.

Helena seems the craziest, her thirst for power the hardest to
satisfy. She schemes and plans for future projects that will add
to their overall control. As the middle sister she seems to exert
a strange control over the other two. She works from behind closed
doors. Public appearances are rare.

The factory lights never dim. The desire for more is insatiable.
What started as a harmless desire has become a phenomenon completely
out of control. Few are enjoying things any more.

There is no fun.

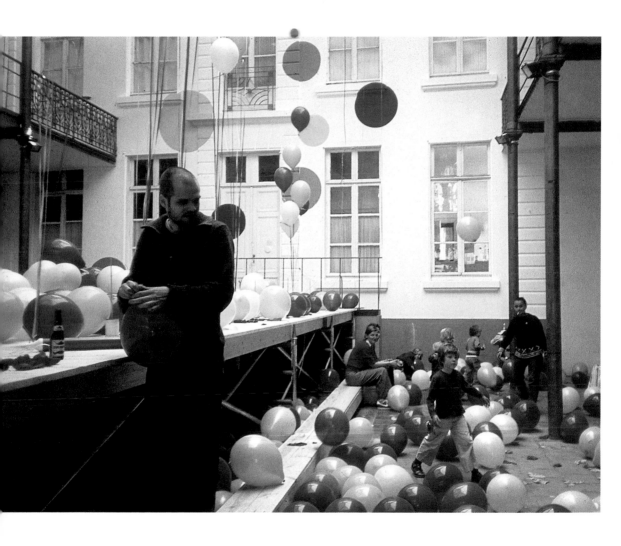

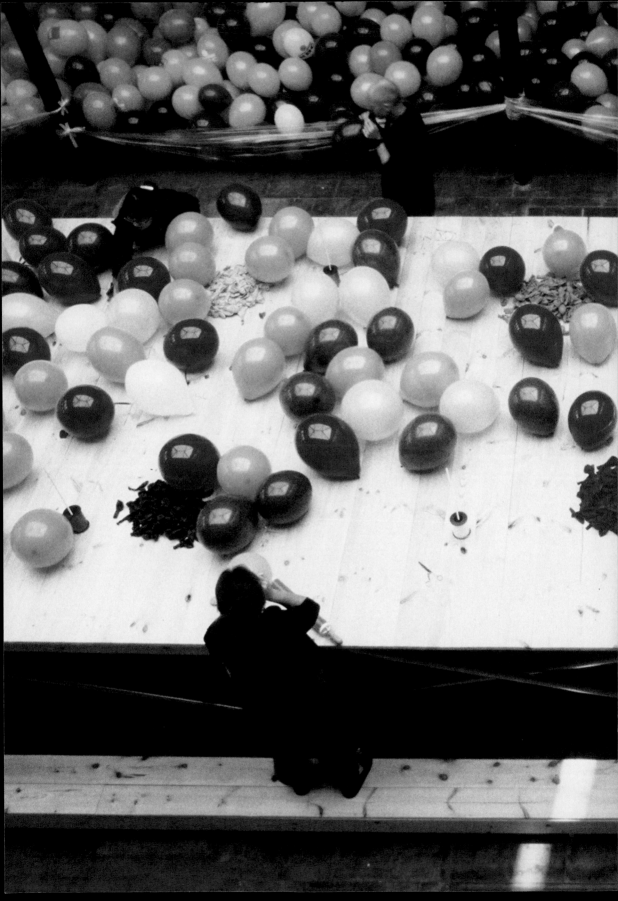

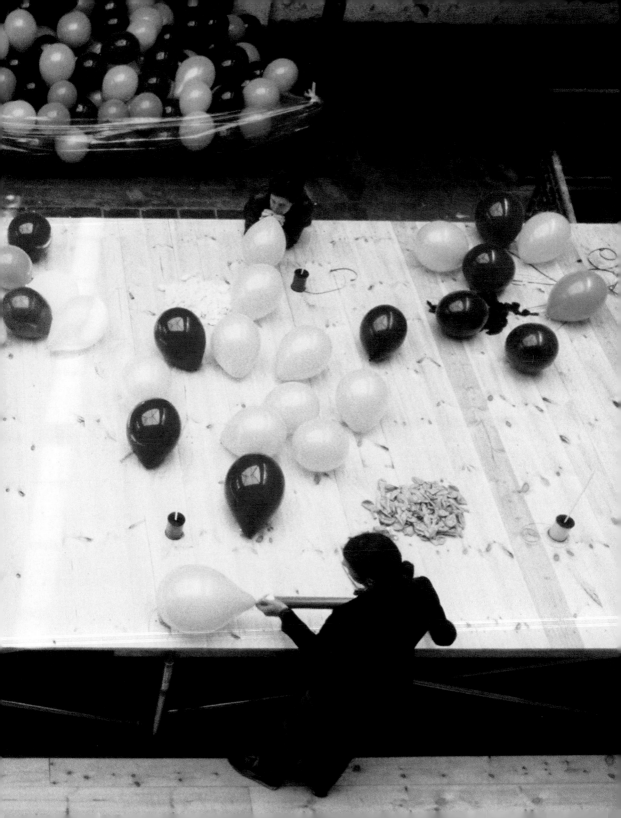

DELIBERATE AND MAVERICK BEHAVIOURS
JULIANA ENGBERG

The modesty of Jacqueline Donachie's books – sized A6, economically designed with attention to smooth, laminate, nice-to-the-touch texture on the cover; coarser paper book endings; matt satin for the images; neat fit for pocket comfort – belies the enormity of the practice they both contain and refer to. Over many years now, on visits to Glasgow, on occasional meetings in other places, when we see each other, Donachie has produced one of these compact, seductive little compendia out of a bag or from somewhere and offers, 'here's one of the books I've produced, you can keep it if you want'.

There is the one with the cover showing two people – formally dressed, he in a black tux suit, she in a white and gold dress with a metallic belt and shoes to match, and a glinty earring that inaugurates a bauble-fest of luminosity in the background, which, despite its location (a concrete platform in a sort of suburban field near apartment buildings) is tantalisingly romantic because the dusk and night street lights co-mingle to glamourise the twilight. The couple dance with earnest intensity, tightly clutching. He leans his body into her, his left shoe lifted, her right shoe also, and she tilts her firm chin to him, as his wire-framed glasses shine dimly.

There is another. This book shows white, silver, grey, alligator skin shoes with toes that have been varnished with pillar box red nail polish peeking out the top. They stand on green grass and a thin green plant stalk, of similar yet different green hue, enters into the picture frame, and adds a special punctuation to the scene. If you turn the book over you realise the stalk belongs to a branch of bouquet 'mist' filler that has been added to red flowers, a greeting card and a purple paper ribbon that now lie on the grass in an abandoned mess. Whereas the former book has a kind of defiant grace, this one has both a vaguely celebratory glitz and a slightly tawdry feel.

Still another. This one a photograph overlooking a kind of communal, vaguely institutional dining-hall. Black wooden tables have been assembled and joined end to end to make a long arrangement, and two small groupings of people are seen talking and eating. The environment is clean, new looking, the floor made from slate or concrete squares. The back continues the scene.

And there are more books – more minimal. A chalk-dust blue coloured jacket, with faded edges, which features a round black speaker; a pollen yellow one of an interior with a light-olive-coloured architectural dado in front of which are positioned metal structures that resemble municipal railings and barriers, but here seem more akin to forms of sculpture; and a crosshatched pressed metal, non-slip surface pattern one, with a rust sheen on the outer edge moving to a more intense blue near the spine that has a sculptural, three-dimensional effect on first glance.

This is a diverse library, the unifying principle of which is the formula of the size and production. The story inside these books is quite different. Whereas the covers tend toward a lush visual, even when they are minimal, the interiors are often sparse. Typography takes over – sometimes randomly, or in patterns, and as short narratives – courier, sans serif, bold, faint, the occasional 'occasion' fancy font. Words in sentences and, sometimes, single words; at times lines that could be best described as snippets. And some photographs, mostly documentary. The odd one out in this library of assortments is the pollen coloured one, which when you look inside offers a kind of catalogue of works by Donachie. The others are and document projects.

These books are important. They keep alive a series of events, projects and exhibitions that

Covers of Jacqueline Donachie's artist's books, 1996–2003

would otherwise be fleeting, ephemeral and even private. As the covers tend to suggest, these projects range between community involvement and an artistic, sculptural pursuit; they involve rituals, sounds, movement and storytelling. They are the quintessence of an approach to art, somewhat a hallmark of the Glaswegian method, which takes art out from the domain of galleries and studio and into the environment of people, places and pursuits. Art and Life brought together and made into something wonderfully celebrated and artistically distilled.

The books are not only records of Donachie's own projects but indicate a historical trajectory of the unique DNA of Glaswegian approach to practice. The Glaswegian Conceptualism; art and text; art and language; the poem objects of Ian Hamilton Finlay; the inventories of Roger Palmer; the love of literature of David Harding; all provide a context for Donachie's lively scat of words that conjure images of bars, the great American road journey, musical pilgrimage, the Quaker pursuit of community fitness, sports rites, music, and natter. And. Of course. Community. That sense of place made by people who pull together and those sets of enactments that are taken from and given to the community to form its rituals and structures.

The books also tell the story of the two seemingly opposite, but actually complementary procedures that exist perpetually in Donachie's approach – the informal and the formal. If inside these little books there is a hurly burly of words deposited over pages; a randomist aesthetic, a rag-tag of characters, snatches and observations of life; there is a clearly precise, formal consideration brought to the artistic outcomes indicated in installations and the documentations that feature as the cover work. This formality and informality are determined by and reinforce the physical practice.

In this aesthetic approach and combine of Donachie's we see the bringing together of strands of Conceptualism: one, the invited randomness that we associate with John Cage and his openness to chance and real life; another, Duchampian, the 'found' and 'readymade' drawn from the industrial and commonplace which has been observed and reinvented into something to be considered; and further, the carefully considered 'specific objects' we associate with many Minimalist sculpture projects. Invariably these strands co-exist in Donachie's work.

The project *Dear Wives* (2002, pp.108–11) provides an excellent example. As an exhibition

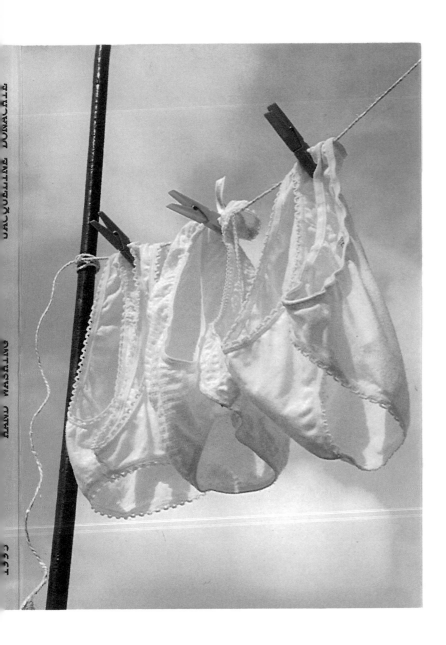

it presents as a series of steel piped railings with key clamp joiners permitting variable length and shapes dispersed about a room, the floor of which has been painted pollen yellow like a field of rapeseed – introducing the requisite Juddian monochromatic. The steel pipe sculptures (low, medium and high, straddling space from wall to wall across a corner, forming a U-beam, and distributed in various ways in linear fashion) assume an arrangement reminiscent of Robert Morris' 1964 installation at the Green Gallery, New York. As his project did, Donachie's objects establish a conundrum of form and function: the low one is ideal for leaning a foot on; the medium heighted one, handy for sitting; the U-beam possibly useful for arm-lifted swinging or other strength games; and the cross-cornered one for hand over hand travel. In other words, a deconstructed monkey-bar environment refashioned as an elegant Minimalism: all referencing the body, whether there, or absent, as was one of the attributes of early Minimalist arrangements.

Dear Wives, alluding to municipal park urban furniture and building, playing field boundary markers, as well as the history of Minimalist installation, invites the visitor into the game. Randomness is welcomed from the viewer who might sit, stretch, prop. Donachie seeks the activation of her space to duplicate the kind of found choreography that she has observed as joggers and fitness followers make use of railings to perform their stretches or take a rest, or people with mobility issues enlist the support and stability of helpful grips. These are props and gestures Donachie has distilled from everyday life, and sculptures fashioned after the readymade of railings, whose purpose has been repurposed by user desires and needs, and now audience interpretation.

There is a kind of rebelliousness in this enterprise also. Donachie takes the mechanisms of boundary control and utilitarianism and perverts their structural power by enticing deliberate and maverick behaviours from her audience. Accompanying the installation was a set of correspondence between Donachie and the Henry VIII's Wives Collective[1], which clearly set out a manifesto of free movement and interaction within the installation – extending and at the same time rebuffing the well-worn conundrum established by sculptors such as Carl Andre whose bricks and metal tiles on the floor deliberately set out to confuse and confound the viewer who is faced with a decision to walk on the sculpture or not – frequently to be humiliated by guards in museums who also do not know.

Home Improvements.

Being inspired by and freeing the audience, welcoming them into her sculptural scenarios, is a constant in Donachie's approach. And she often oscillates between which is the formalised element and which is ad hoc. An example might be *Games* (2003, pp.126–31) where the makeshift, sports structures of highland games (coiled ropes, tarpaulin draped podia, obstacle-race tyres, make-do fixings, holdings, and burlap swing bags) are 'found' and recognised by Donachie, and via her nomination ushered into the pantheon of *Live in Your Head: When Attitudes Become Form*-type structures – particularly those that were referred to as 'non-rigid' art at the time.[2]

Donachie in this gesture exposes the origins of the real life situations of the 'new' sculptural aesthetic derived from humble materials created from a tension between the purposeful and the contrived. Donachie's anointed naïve sculptures, born of the athletics field, are juxtaposed with the formality of the games themselves, with their adherence to rules, formulas and strict guidelines and patterns – a sort of found choreography which adds a performative, participatory element to her list of conceptualisms.

Donachie's practice, when she assigns artistic status to ordinary things, seems to be the quintessence of Goethe's observation 'What comes into appearance must segregate in order to appear', quoted by Robert Morris at the beginning of his influential *Notes on Sculpture*. Yet it is also the case that she gestures towards the ideas espoused in Joseph Beuys' concept of 'social sculpture' to the extent that she embarks comprehensively on the interplay of things to produce, a *Gesamtkunstwerk* where such privileged designations of the ordinary collapse again into their social origin to reinforce a sense of life connected by and influencing social outcomes.

Beuys believed in art having social purpose, having the power to shape and transform society, and when he spoke about 'social sculpture' he implied a gesture that influenced outcomes for social order. Much of Donachie's work has a usefulness to it and this is linked to a politic of community spiritedness. The concrete platform upon which her twilight dancers perform, for instance, was planned as an every-day, every occasion platform – a playground space for invented ball games, performances, and as we see from her book *Kenny's Head*, the occasional 'ballroom' dancing.

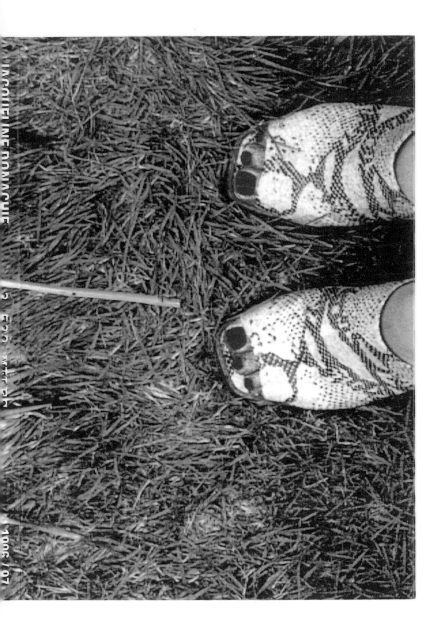

Kenny's Head, the book, is the second part of a project entitled *The Trees, The Book and The Disc* (1999, pp.64–71), Donachie's art project responding to the redevelopment of the Darnley estate in Glasgow. It is a project in which her approach to art as a social project becomes clear in its provision of a public gathering spot, and the interaction she imagines on behalf of a community that combines sports with arts and leisure – a place for everyone.

The other aspect of Donachie's approach that becomes a standard is her deliberate embedding of herself in a community. Her projects evolve from residencies, sustained visits and much research – and perceived need. For example, her creation of a minimal sculpture in the form of a large, concrete, internally heated disc, *South* (2001, pp.78–81), built in situ as part of her Henry Moore Residency at Spike Island, Bristol eventuated as a result of her seeing the need for a collecting spot for the studio artists who tended to be isolated in their individual zones. The central heating of the sculpture provided a warm haven in the chilly environment of Spike Island's former tea packing hall. And like her Darnley platform, the disc also became the site for performance and games: a place for a performative python, and a platform for skateboarding kids in sympathy with the

Duchampian gesture of inviting children to play football in his installation *One Mile of String*, the centrepiece of the *First Papers of Surrealism* exhibition in 1942.

These days this kind of gesture would be referred to as 'relational aesthetics', but Donachie's ethos has been informed by a longer trajectory of practice that embraces the spirit of the aforementioned conceptualisms, minimalisms and the planned, yet randomised events dubbed 'Happenings' by Allan Kaprow in the 1960s. And again these types of gestures could now be called 'crowd sourcing' and 'participatory art' – or 'co-curation' in festival speak – but that would be to twist the meaning of Donachie's works which retain their authenticity as participatory art actually made in an effort to bring art and real life together in the social sculpture of the *Gesamtkunstwerk*.

The project *Huntly Slow Down* (2009, pp.158–65), and the larger iterations for Melbourne and Glasgow, provide strong examples of the strands of research, planning and outcome that go to make up a Donachie work. The aim of the project was to see if it might be possible to turn the small market town of Huntly into a car free zone and to reinstate a sense of

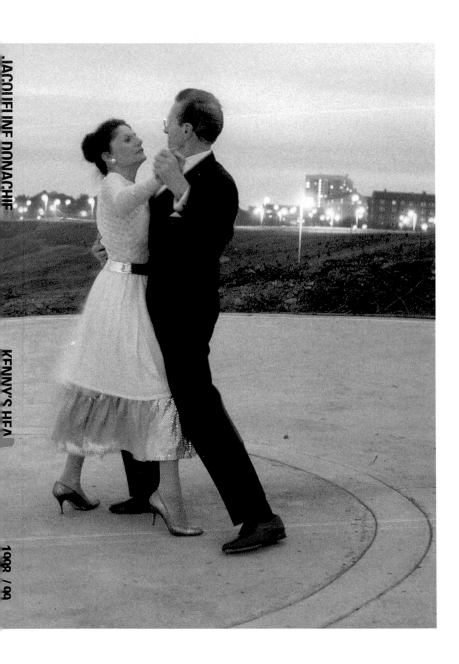

community space in the urban centre. In order to attempt this, Donachie studied twentieth-century town planning to understand how and why a place like Huntly had lost its community spaces – town squares, for instance – to cars and their parking, and as a consequence become areas of disaffection: grungy, anti-social and unsafe.

To activate this idea Donachie undertook community, business and local government consultations to begin a discussion around the introduction of a car-free place. The project eventually became a community ride and festival involving some 200 participants, the closure of the city square, cycle workshops and other activities including (through the addition of a coloured chalk pour attached to the bikes) a 10-kilometre urban drawing that demonstrated the desire lines created by the free-wheeling free zone bike users. This inspirational project highlighted needs and solutions to an urban issue and commenced a movement towards a more sustainable Huntly. The variations in Melbourne and Glasgow each represented an extension of this approach, with conceptual drawing being an anchor in Melbourne in 2013, and the idea of participation and an every-persons 'Games' in Glasgow around the time of the Commonwealth Games celebrations in 2014.

Alongside all these large and involving works, Donachie has been pursuing a quite personal project for some time, applying the same research rigour, participatory aspects, and formal and informal solutions central to her methodology. This work, which has evolved to now comprise exhibitions, video work, photographs, drawing, sculpture, and years and months and hours of research and conversations with medical teams and strangers, relates to the particular DNA that passes through her family: resulting in myotonic dystrophy, a neuro-muscular disorder. Donachie's quest has been to learn. To gather knowledge and try, along with professional medical people and the affected, among them her brother and sister and many in her extended family, to fathom this inherited disease and to understand its impacts. It is a symbiotic project. Donachie is free of the condition, but maintains a vigilant connection to it as she prepares, with her family, and in particular with her sister with whom she has a close bond, to meet the future of this debilitating and degenerative disorder.

The sister in her wants to help. The artist in her wants to order this disorder in her formal language. The social artist she is wants to reconcile the two approaches. Sculptures, videos,

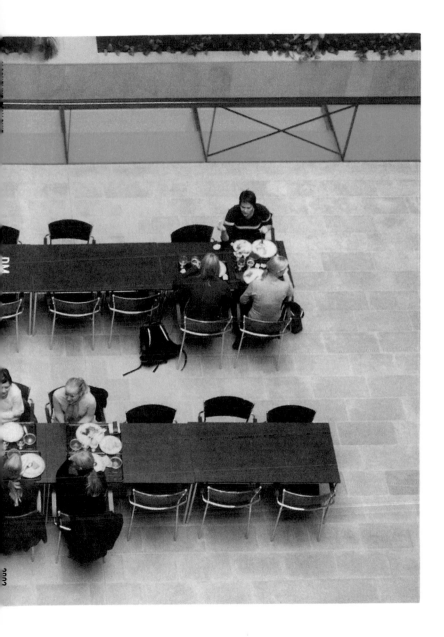

drawings become symbols, metaphors and distillations of the condition in the language of Minimalism, portraiture and a kind of body baroquery that speaks from a knowledge of balance, symmetry and asymmetry – the formal and the informal, the rigid and the non-rigid – and in the video work *Hazel* (2015, pp.242–47), the talkative and the silent.

Her recent works – sculptures that combine the rigid and non rigid, collapse or have internal destabilisation and use visceral materials – are body surrogates and deliver enormous pathos. The video work *Pose Work for Sisters* (2016, p.239) continues this investigation of the stable and unstable with the artist and her sister posing – one strong, defiant and demonstrating stamina, the other vulnerable, buckled, in need of support. Despite their toughness, these works are tender, even humorous, and as usual succinctly profound in their capacity to communicate their subject, which while personal, becomes universal.

It is hard to imagine how this enormous art practice might settle into a major monographic gallery exhibition. But Donachie will no doubt find a way. She will probably set up an 'Advice Bar', as she did in 1995 in her early days on a Fulbright scholarship in New York offering drinks in exchange for problems. These bars enable her to work her way through any number of issues brought by the public, some of whom will no doubt be seeking an informal way to find the formality for their own asymmetric existence.

Ever hoping for a social sculpture that can be useful, Donachie listens, records and segregates in order to make appear, while she also delivers the issues and ideas back to the community from which they came in a very sophisticated approach and practice that lives lightly – like the fluttering words on a page inside a small book.

ENDNOTES
1. Henry VIII's Wives was a Scottish/Scandinavian artists' collective founded in Glasgow in the late 1990s.
2. 'Live in Your Head: When Attitudes Become Form (Works – Concepts – Processes – Situations – Information)' curated by Harald Szeemann, March 22 – April 27, Kunsthalle Bern, 1969.

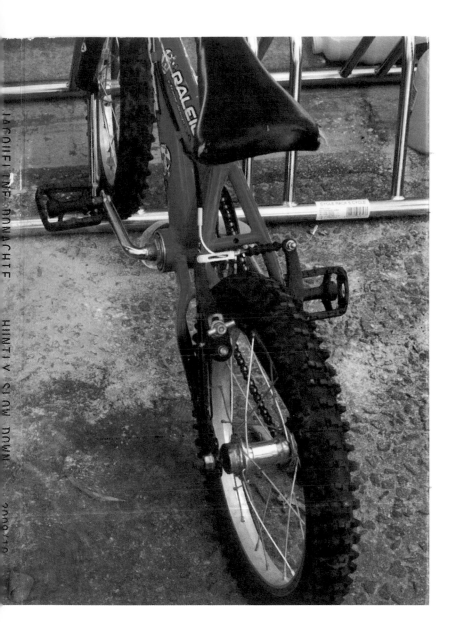

JACQUELINE DONACHIE *NEW WEATHER COMING* 2011

THREE PINKSTON DRIVE 2002

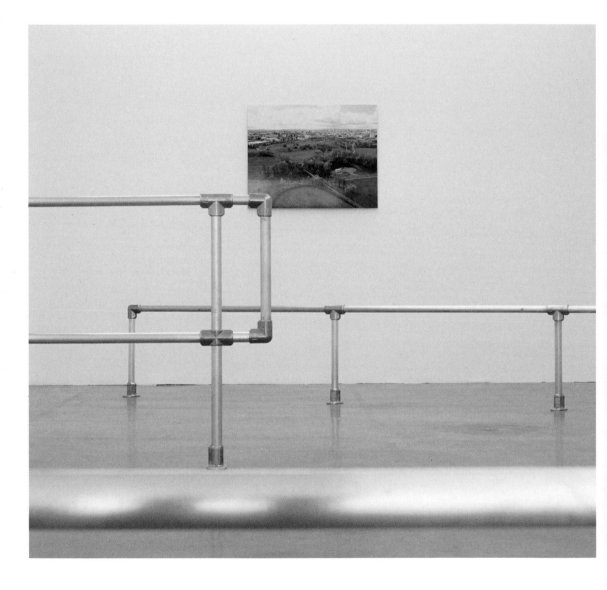

This work was based on a period of research undertaken in the Sighthill housing estate in Glasgow,
that has, over a period of several years, become home to increasing numbers of asylum seekers
Aluminium tubing, digital photographic print mounted on aluminium
Whitworth Art Gallery, Manchester; FRAC Languedoc-Roussillon, Montpellier

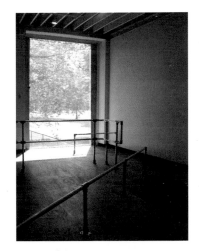

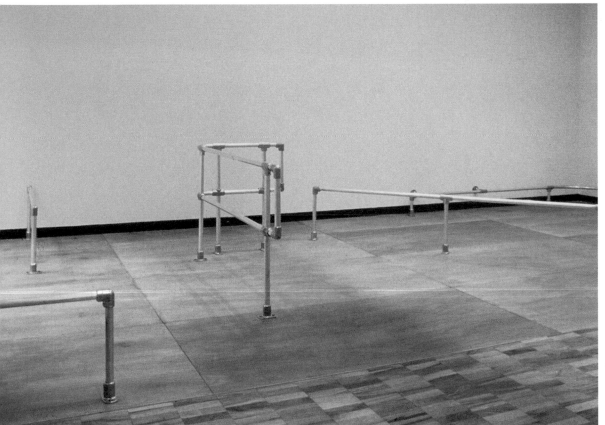

DEAR WIVES 2002

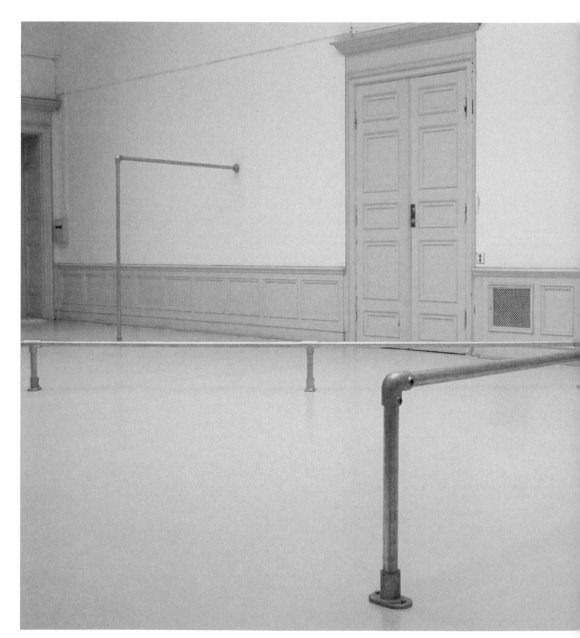

…I think I heard someone say that it was important that people could walk on it and move about freely, which is something that I've always thought of as very important in my work. If you say, yes, this is for people to walk/sit on, there's nothing worse than having an invigilator running after you saying, oh, but it's only one at a time, and you can't take your drinks, and you must take your shoes off first … that really is the worst of all. I just can't abide looking at art in my socks. But it's very Nordic. What's that all about? We keep insulting people here by walking into their houses and keeping our shoes on. Not deliberately, we're just not as fastidious about it as the Scandinavians. I think it threatens our Scottish protestant roots, makes us feel too vulnerable to be in non-intimate company without our boots on - what if we had to make a quick getaway? Or someone steals our shoes? I think most Glaswegians I know have a real problem with it, it's funny how such a small thing can become a big deal, set nations apart as it were. I guess we don't have such nice floors, or maybe just not enough respect for them. But we are impressing the importance of it on Archie. We've told him it's the Golden Rule of Sweden - always take your boots off.

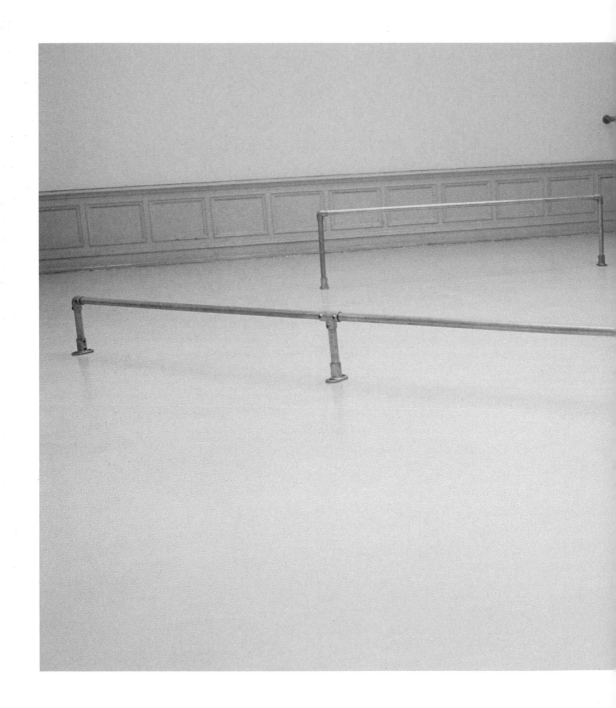

Steel tubing, painted acrylic floor, text leaflet
IASPIS Gallery, Stockholm

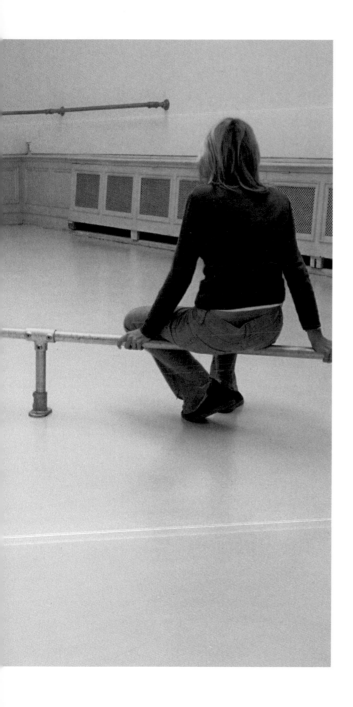

DM 2002

Artist's book

All my life I've been told how much I look like my sister.

Are you twins? Which is which, I can never tell?

We never saw it. I was younger and for most of the time rounder (I burst her leather skirt in 1986 and she never let me forget it …). And she's a few centimetres shorter than me, which for tall girls in the inherently stocky West of Scotland is a big deal. When we were both expecting babies at the same time - her second, my first - our bellies swelled to exactly the same shape. She was three months further on than me though, so for a while at least I was smaller.

Then she had her baby.

The baby wasn't so well.

Born very prematurely. It was all a bit of a panic. After our initial fears for this tiny thing (3lbs 2ozs, I was there to see her come out) that were inevitable due to her arriving almost eight weeks early, more fears were raised.

After samples and tests and lots of questions, it turned out that the baby had something that she had inherited from my sister as well as her hazel eyes. In time we found out that my sister had inherited this thing from my dad - who was also the one with the hazel eyes, incidentally. Until this point none of them had been aware of having anything. The scare at the time was aggravated by the fact that I was also expecting a baby and, because my sister had unknowingly inherited this thing that she had passed onto her daughter currently very sick on a tiny ventilator in a plastic incubator in a very large hospital, then my unborn baby and I were also at risk.

But it was not to be.

After more tests and more waiting and more kicks from an ever-fattening belly I was told that I didn't have the thing that they had. It wasn't just the hazel eyes I didn't get from my dad (mine are plain old blue, like my mum's). And because I didn't have it, it was impossible to pass it onto my son.

So that was that.

In the months that followed my sister's other child was diagnosed with the condition, as was my brother, and we all started to notice funny wee things like the fact that Susan could no longer walk on her tiptoes, which made for a laugh as we all tried it, up and down the kitchen floor at my parents' house.

Round about this time my mum started to smoke again.

Since that year we've found out more about this thing that they all have.

And it's a funny thing.

It grows and repeats itself throughout your lifetime, and the severity of symptoms multiply as it passes through generations; the type that my niece got from my sister is worse than the type that my sister got from my dad. The age of onset of symptoms gets steadily younger, although you can only inherit the congenital form, like my niece has, from your mother. So my dad's symptoms are appearing now that he's in his sixties, my sister and brother are developing problems in their thirties and my niece and nephew have problems all the way from childhood. Which means that three years ago we knew nothing and now it's kicking in for them all at the same time.

At first it was too hot and our meetings got cancelled. I had brought all these people here, away from their very varied and busy lives, to stay in a crummy Comfort Inn and walk the streets of Montreal looking for something to talk about as well as this disease that we all had in common. We sought out air conditioning. The geneticists marched us all off to the Science Museum and later that day I dragged them to the Museum of Contemporary Art. We were sceptical but respectful of how each of our worlds were portrayed, but felt better for this unplanned bonding. The cold beer was good and it made Susan and I laugh that the scientists kept asking her if she needed to have a rest.

We went on to meet families that were much better and families that were much worse than our own. The families that were worse scared the shit out of my sister and I and the families that were better made us feel good. One family had an unaffected sister who had given up her whole life to care for them all. My sister told the scientists that they'd better get working on their bloody cure and I just felt sick.

As I said it's a funny thing this disease. It can affect many different people in many different ways. We swapped a lot of photographs, drew family trees on dinner placemats, and gave out a lot of highland toffee. After eating blueberries with two sociologists who study the cultural and economic effects of the condition on the families who have it, we swam in Lac Saint Jean with an eminent neurologist and his genetic counsellor wife. He barbecued us lamb chops and we talked about fly fishing, dodgy hands and the big clinic he ran in the area.

We never met anyone who recognised us.

A WALK FOR GREVILLE VERNEY 2003

Live event: a walk for walkers in the spirit of Greville Verney (1869–1923), the 19th Lord Willoughby de Broke and the last of the family to live in the stately home. Including a republican pipe band, members of Greenpeace, the Campaign for Real Ale, historical re-enactors, animal welfare charities and the local hunt. Compton Verney, Warwickshire.

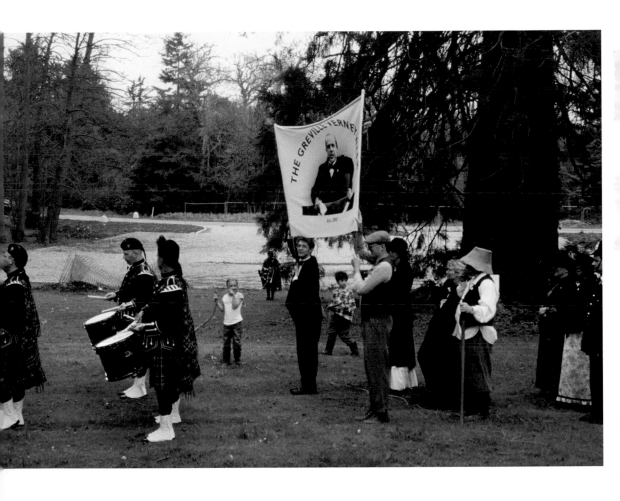

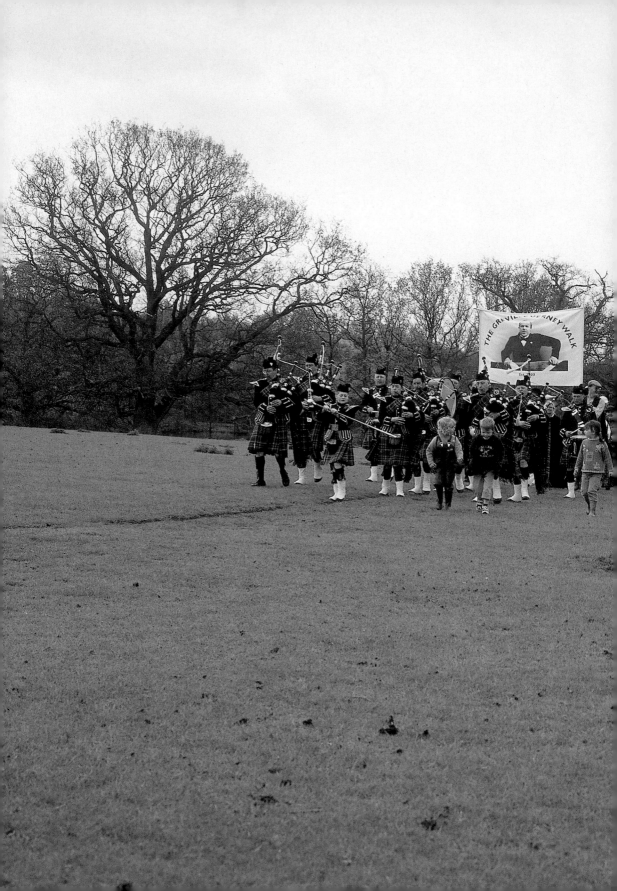

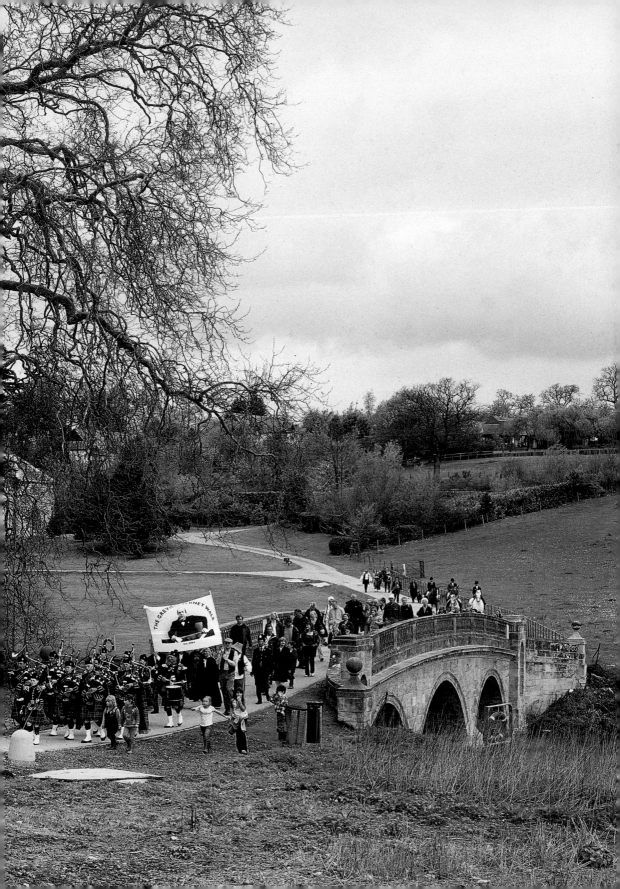

GAMES 2003

Series of digital colour prints, 15 x 20.5cm each
Glenfiddich Distillery, Dufftown, Moray

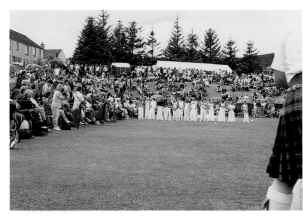

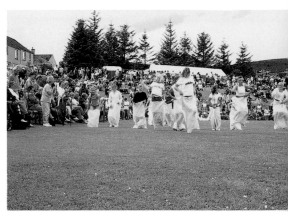

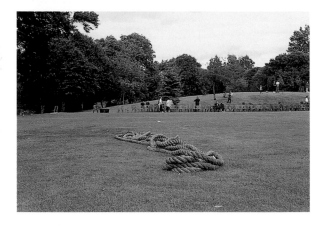

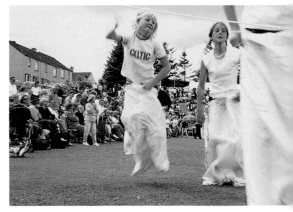

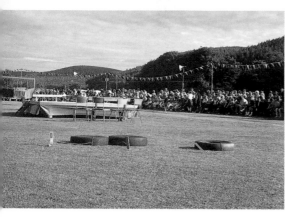

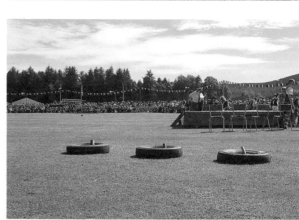

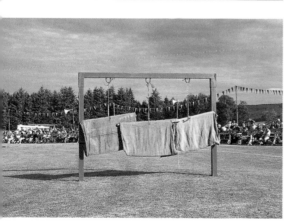

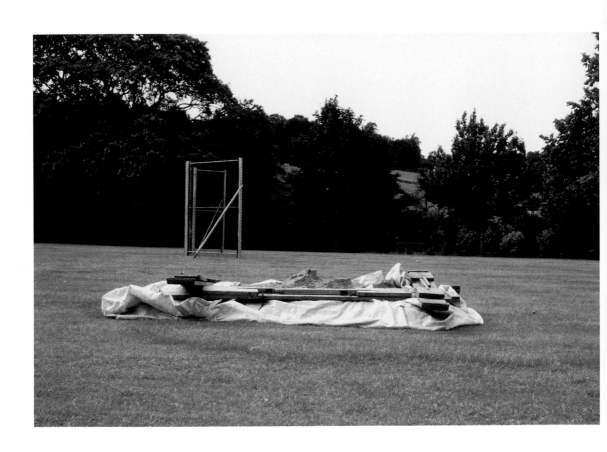

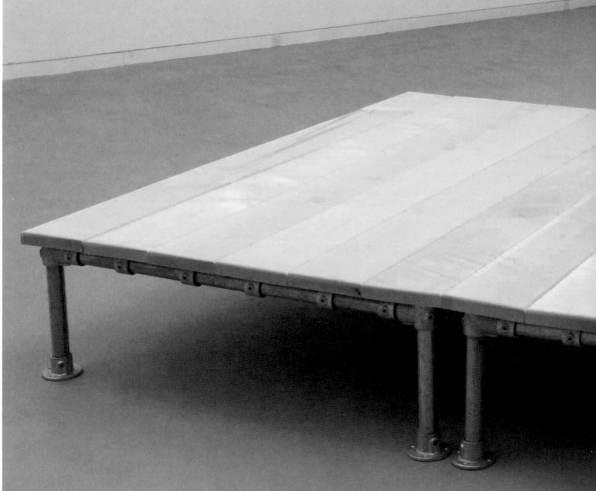

GREEN PLACE 2004

Sycamore, steel tubing, three photographs mounted on aluminium
Contemporary Art Society Commission for the Whitworth Art Gallery, Manchester

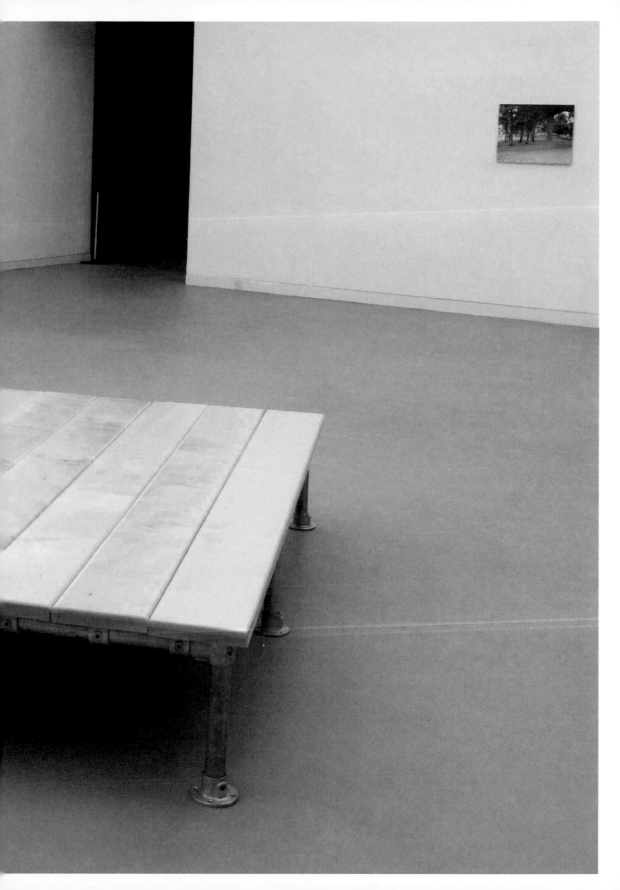

TOMORROW BELONGS TO ME 2006

Tomorrow Belongs to Me (still), digital video, 18 minutes
Premiere screening at the International Myotonic Dystrophy Consortium Meeting, Quebec, 2005. Film, book and
exhibition in collaboration with Darren G. Monckton, Professor of Human Genetics at the University of Glasgow

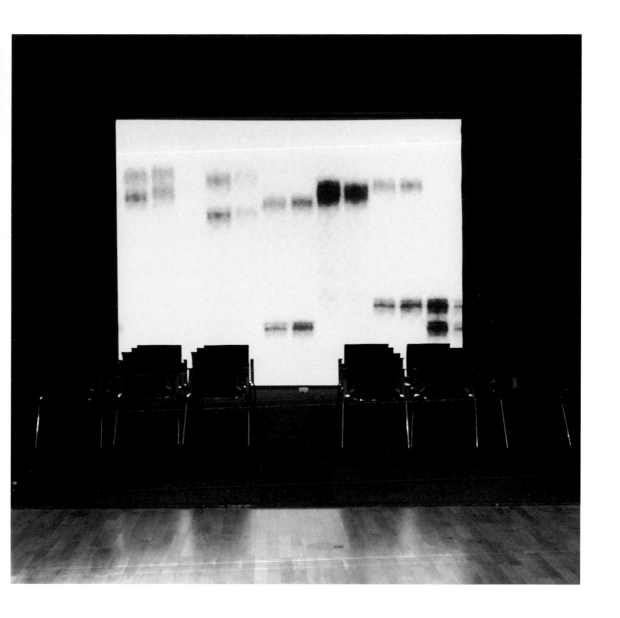

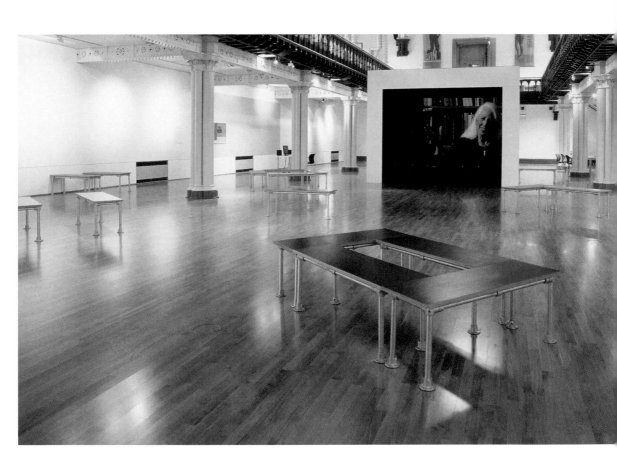

Tell Me About Your Father's Side, 2006, installation view from *Tomorrow Belongs to Me*
Lacquered plywood and steel benches, each 40 x 122 x 50cm
Hunterian Museum, Glasgow

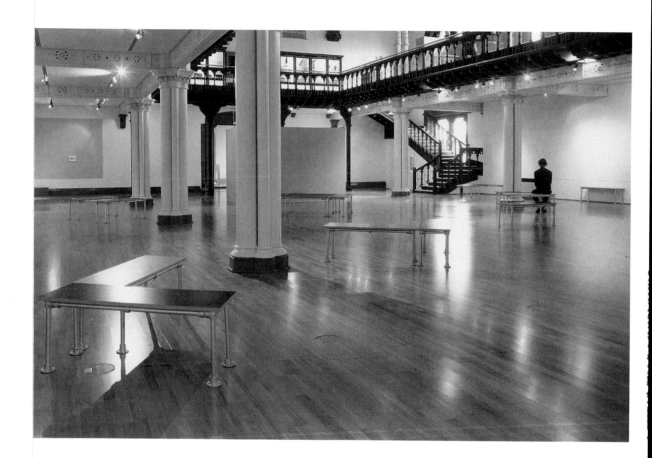

WEIGHT 2008

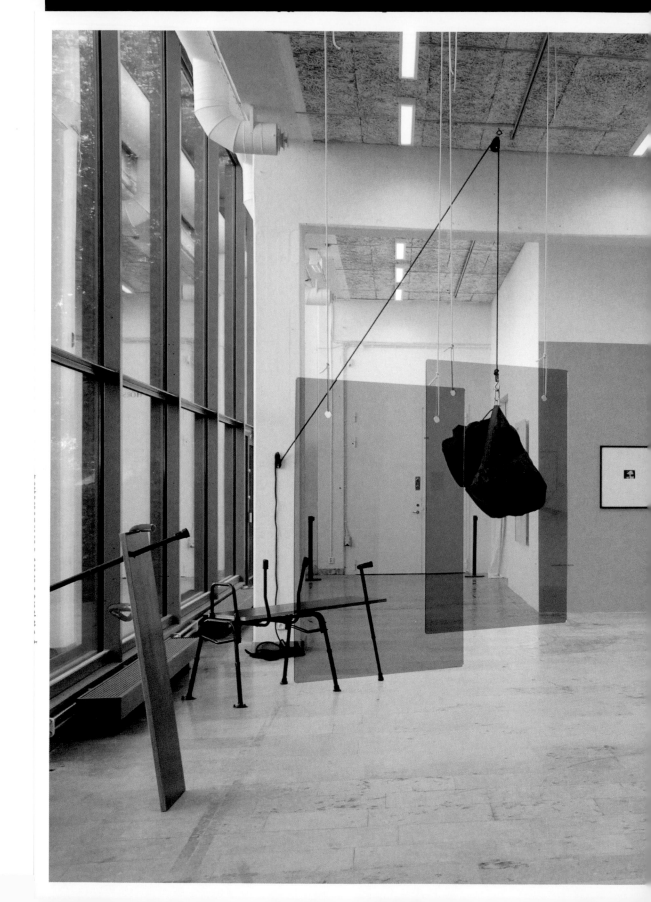

Preparatory drawing for *Weight*, 2008
Ink on paper, 29.7 x 42cm
following: Installation view, *Weight*, 2008
Gothenburg Art Museum

138

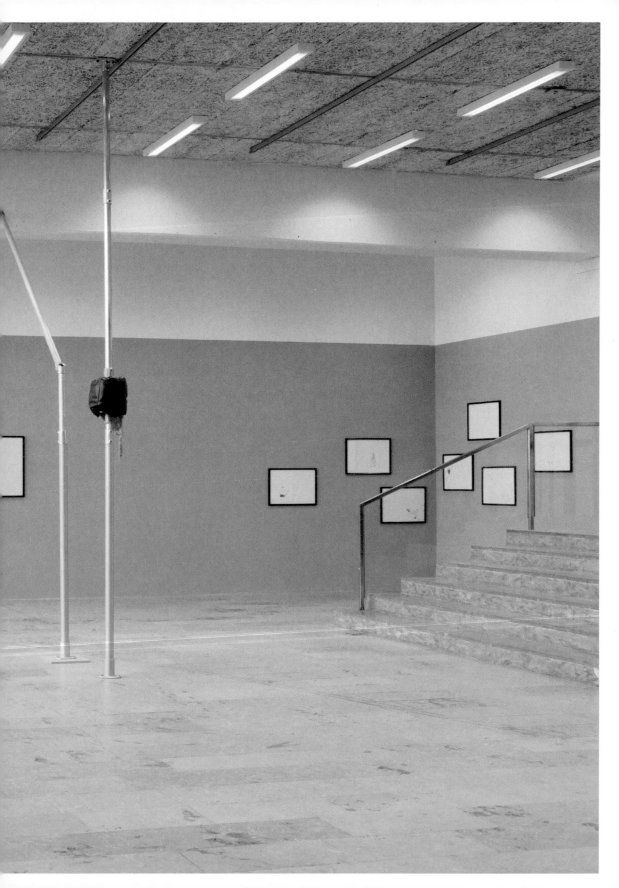

Weight, 2008
Series of 8 drawings, pencil on mapping paper, 62 x 45cm each

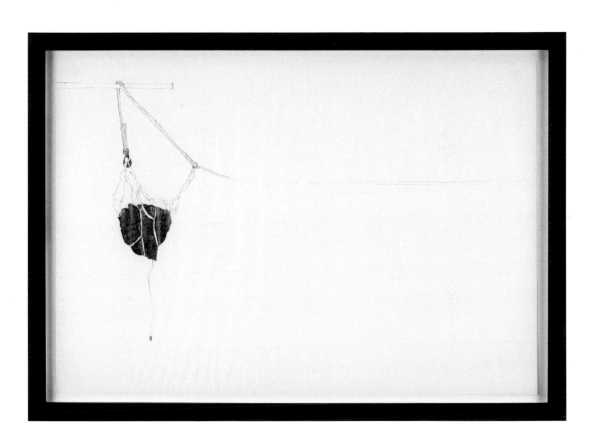

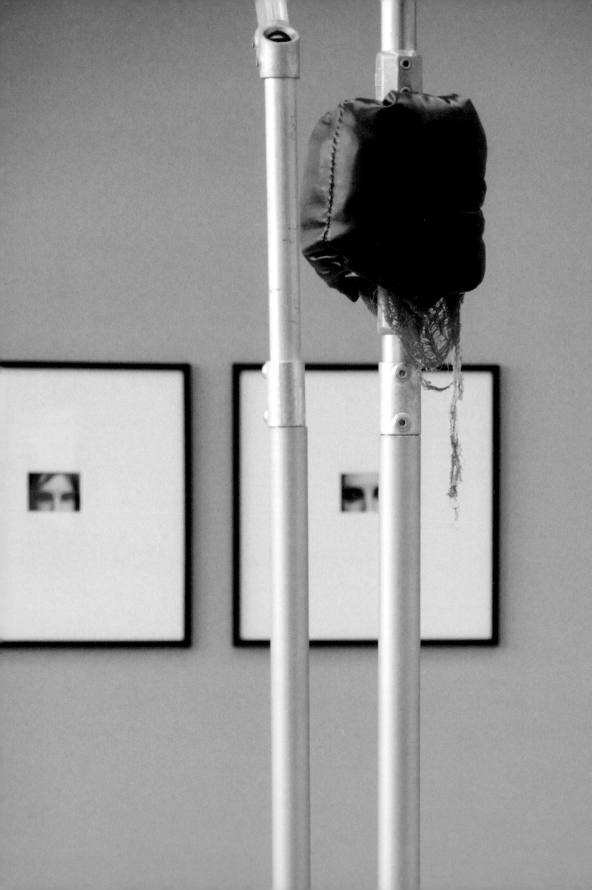

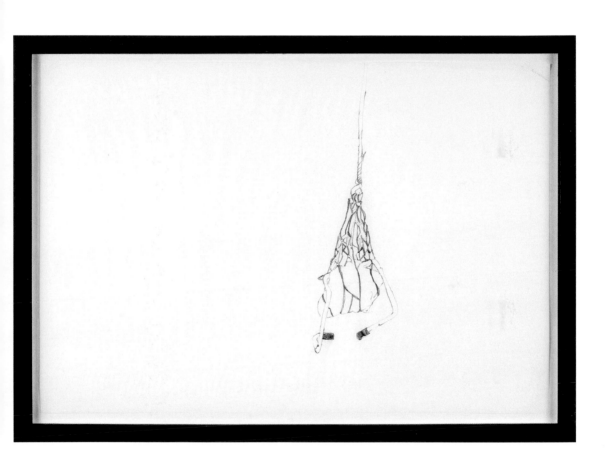

left: *Winter Trees* (detail), 2008, aluminium, steel, vinyl, cotton, spray paint, dimensions variable
above: *Weight*, 2008, pencil on mapping paper, 62 x 45cm each

Susan's Eyes, 2008
Photographs, 70 x 70cm (framed)

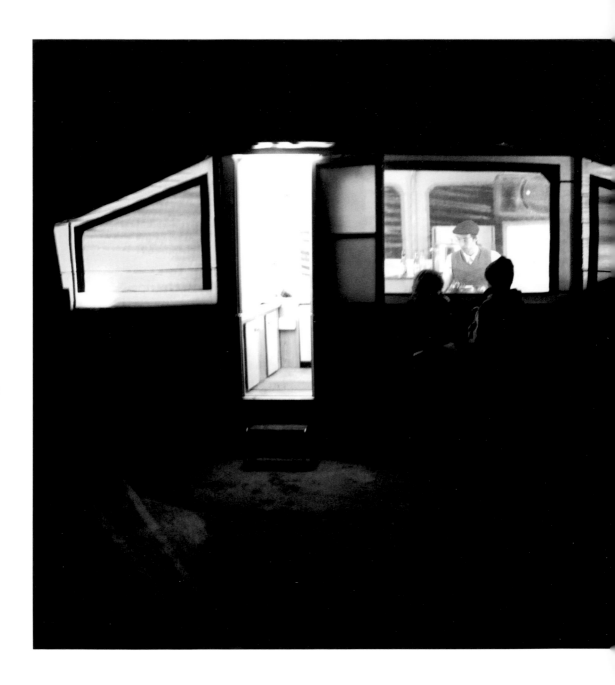

Decommissioned Trailer, 2009
Installation and live event: adapted trailer tent, DJ, amplifier, lights, turntable, records
Glasgow Sculpture Studios

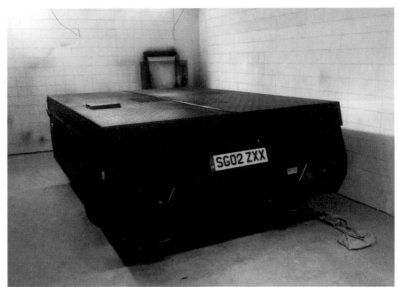

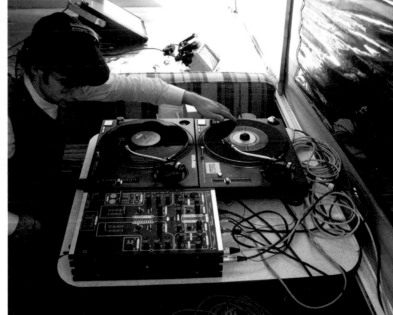

SOUTH (HIGHLAND) 2009

Permanent public work: heated concrete disc, 8m diameter
Centre for Health Science, Inverness

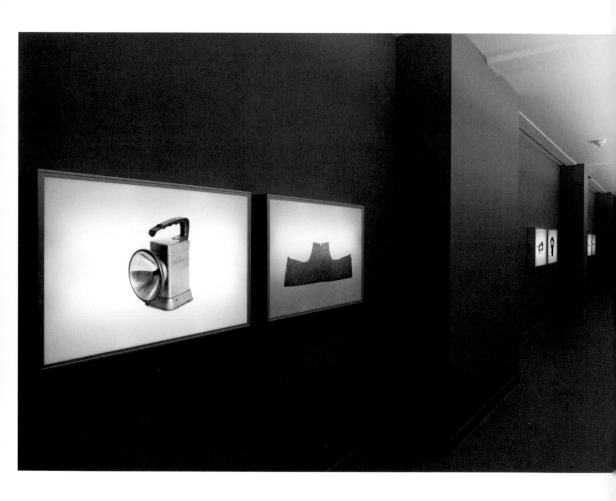

The Collection of Etta Campbell, 2009
Light boxes, 76 x 61cm each
Clinical skills training wing, Centre for Health Science, Inverness

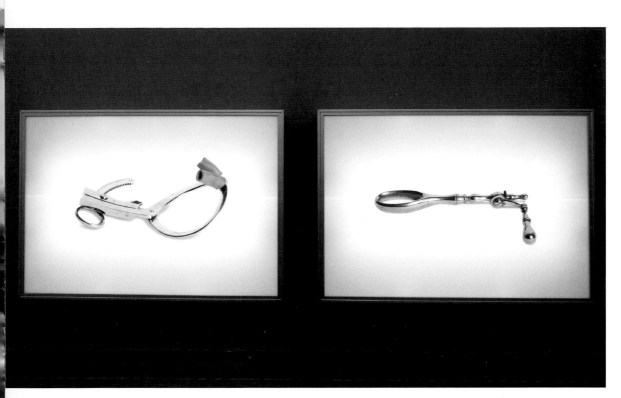

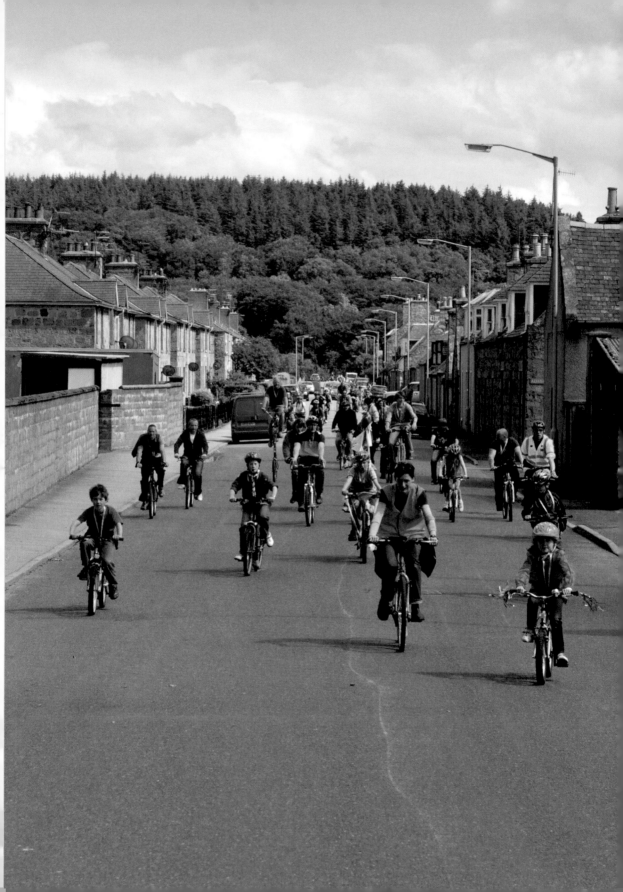

And the other main street, the one that crosses the square from the other side, that has most of the shops including delicious ice cream, butchers, bakers and a fine selection of malt whisky, that street, Gordon Street, is also the A97. So the town square is the intersection of the A97 and the A920.

Does that make it a square or a major road junction? Or maybe it's a car park now - it also has 20 parking spaces. What happens when you take the cars away then?

Beautiful things.

Gentlemen read newspapers, drinking coffee. A cellist plays Bach. We learn Tai Chi. An artist gives you a historic tour of your own town. There's a blanket for your knees if you feel cold.

How do we make it safe? We think about a lane for bikes.

Where do we want to go?

EVERYWHERE!

To go everywhere we need a path that goes everywhere. The discussion grows. We mark it on maps and talk about it in meetings and eventually there comes a point where we just need to DRAW it (we are artists, after all).

We talk about cars, we talk about bikes, we think about how to make it good fun.

As I said at the beginning - it's not really about SLOW, it's about FAST.

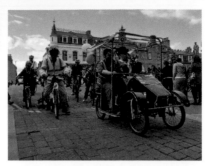

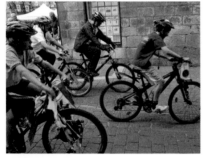

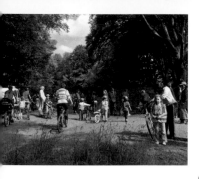
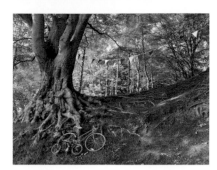

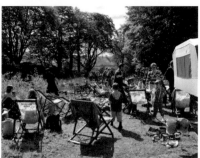
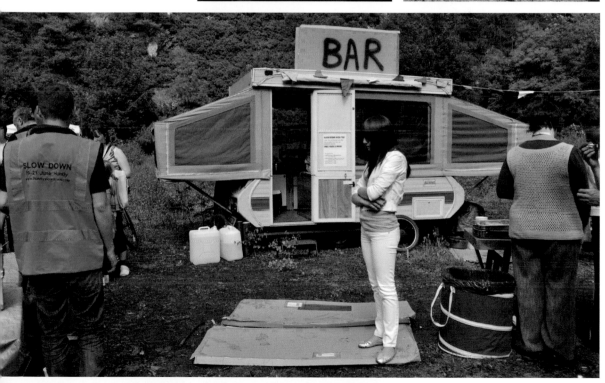

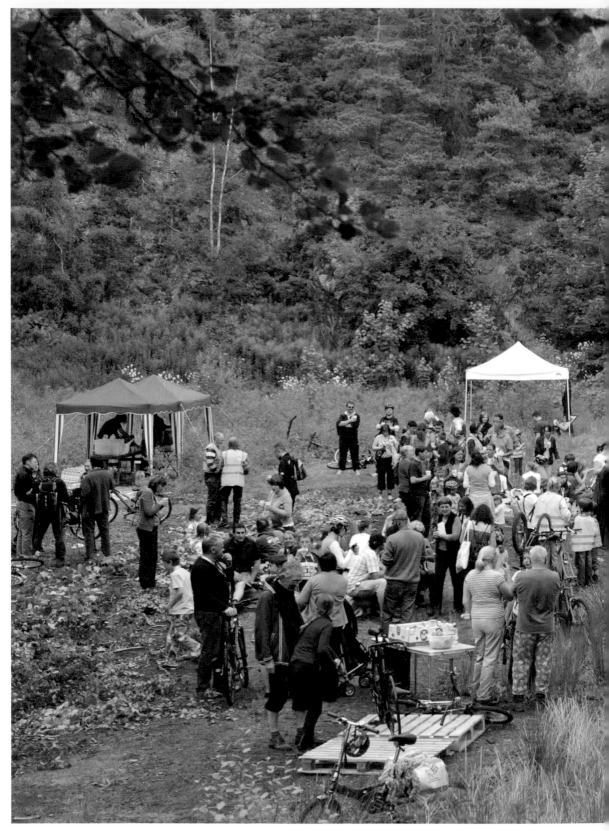

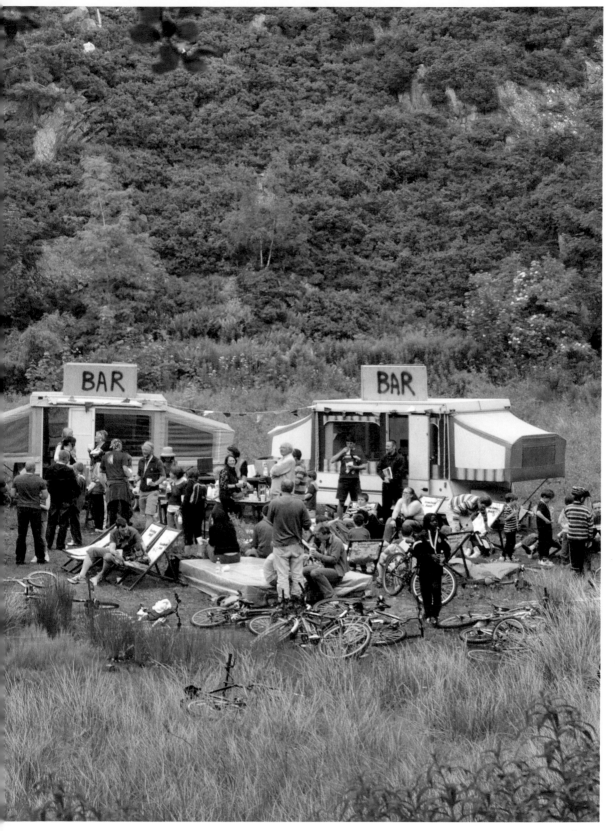

JACQUELINE DONACHIE
AND
PHYLLIDA BARLOW
IN CONVERSATION

about the work you have made that relates to genetic illness in your family. You mention in one of the interviews I read in preparation for this conversation the notion of creating a distance between the subject and what the object might be and how you interpreted that distance emotionally. If one is at a distance (there are a lot of phrases around the word distance – from a distance, at a distance, keeping a distance, etc.), what happens in the gap between one thing and the other thing? Is the thing that's at a distance also looking from a distance at the thing that wants to be at a distance? In the sense that there are two things in play there.

JACQUELINE DONACHIE: Like the subject and the objects?

PB: Yes, in a way there are more than two, there are perhaps three things in play.

JD: Yes, there are. There's me, the subject and the objects. I hadn't thought about it in those terms, but you could say that you could use distance to protect you from a certain subject. But then you could just not make work about it, and then you wouldn't have to deal with it at all. I can't really say, for example, that I need to create a distance to protect me from what's happening in my family by making

PHYLLIDA BARLOW: I would like to begin with the back story of your work – how your subject relates to your objects. I'm thinking

these abstract objects, because I also have the choice to not make work about it at all. I don't need to make work about what's going on in my family life. But, actually, I've always seen a direct connection between public works, solid sculptures, metal railings and family genetics (it's not really the right word, but it's the word I'll use for what's going on in my family), even before anything was diagnosed. It's all there, you just need to get on with navigating it.

So, the point that I use as a reference to what's going on in my family is me. That's always been part of my practice. It goes in waves. I used to make a lot of work about being tall, for example, something that you can see in the *Studio* (1995) print, which is a picture of my studio wall just before I packed it up to go to New York (cover). It includes lots of writing and photos around relative height that were reflective of that time. It was all about me. It was nothing to do with illness or my family. So to revisit that in my work twenty years later puts a different perspective on it. I think there is a distance there but it wasn't something that I deliberately set out to do to protect myself.

PB: No, I didn't see it as that. I saw it as a fascination that there can be such a powerful identification with something real in your life, that can become the subject, that can be taken hold of, and the taking hold of it can be transferred to physical things. I am curious about an artist who doesn't have to hunt for a subject. I have to. I have no idea what the subjects are in my work and it's a torturous process coming to terms with what I experience as a loss – of never being able to find that thing to take hold of in the way that you do. And, therefore, my question is whether there is an equivalent sense of loss when one of your objects is actually made because it may not be understood, the subject may not reveal itself. Perhaps we have something in common, but start from opposite ends.

JD: To meet in the middle?

PB: There is a meeting point between a process that has a subject and one that doesn't. And it's not a negative thing, it's a very sensual positive. The tragedy of the sculptural object. That it becomes so much its own self that it loses …

JD: the history of what's gone into it.

PB: Yes.

JD: The way I think I see it is that I have a

history of things that go into the objects that I make that you don't think you have, but you're still able to look at my objects and take something from them. When I look at other artworks I probably get more from them if I know something about where they have come from, or what has gone into the process of making them, or the process of researching them. But I don't get hung up on deeply conceptual artworks if they're not doing it for me in a visual sense, as well. I like the idea that the work exists without me standing next to it talking about it. That's really important.

PB: The course in Glasgow that's so renowned, the Environmental Art Course. What is so particular about that course?

JD: You had to put your work outside. Once a year you had to make some art and take it outside. The first year you could just take it and hold it, you didn't need permission for it to be there. In the second, third and fourth years you had to have proof that you had negotiated permission to have that artwork out in the public realm for two weeks. By the time you got to the fourth year you had developed really good negotiating skills (I remember negotiating with a bus shelter company in an industrial estate in Cumbernauld) which in turn enabled you to do a better degree show. Not better in terms of art content perhaps, but you were better able to deal with an audience. At the time, we all railed against it.

PB: My training was in sculpture. It was a traditional, conventional and orthodox experience in terms of defining sculpture through the five skills. Clay modelling, casting, stone carving, wood carving, and armature construction. And I couldn't do any of them, apart from working with clay. Although I reneged on this traditional education, I eventually became very grateful for it from a practical point of view because it gave me independence when I left art school.

JD: To make things?

PB: To make things, yes. And I also think there's something about art school departments – the department of sculpture, the department of painting, etc – that has a validity, even if you hate it. Being able to repudiate something is possibly the most powerful thing you will get out of art school.

JD: I agree with that.

PB: I'm curious about the notion of indulgence

of the artist who works privately, who is experimenting with their own inner thoughts, generating this private relationship with their imagination and how it becomes realised through whatever their preferred medium is, compared with somebody who is committed to the public space. I'm just curious about how this difference operates.

JD: I think I do see making work in a studio with no necessary outcome as a bit of an indulgence. When I made my recent street light drawings (pp.199, 202, 203, 254), I had to spend extended time in the studio. The drawings were in my head, I knew I wanted to do them and I was sure I would be able to do them and I'd planned the scale. But then it got to the point where I actually had to do them, and I felt a sense of dread at the thought of those very long, quiet days in the studio. And I know so many artists who are always saying they are sick of going to meetings, sick of public art, sick of meeting the community, sick of architects. They just want time in the studio. Whereas I'm quite happy to go to lots of meetings. I don't really love that enforced time in the studio, making stuff. It's not something I crave. I think part of that is that I think of it as a bit of an indulgence because, for me, I've never been able to earn my living exclusively through studio work.

PB: It's very refreshing to hear that.

JD: So, I think that certain aspects of my practice have been quite neglected because of that, but there are lots of other ways you develop your antennae and your skill base. You have to develop. You can't just stay the same as you were when you came out of art school. And the skills that you get at art school, that you talk about, Phyllida, we did get those, but we also got this default training in negotiation. And if I'm teaching now, I always talk about the skills I got then – editing, negotiating and being able to communicate with people – and I emphasise the importance of being an artist in the world. I know there are some really gifted artists that can live in a certain bubble, but sometimes I get tired of the cult of genius. I think that's partly why some artists – mostly women – just get on with it. It's too much of a luxury to have time just to make work in the studio. There was a great piece on the writer James Kelman last weekend, one of these columns in the newspaper on 'how I write'. And he said something like: I write between five and eight in the morning. Always have, always do. Because I've always had to work, as well. The concept of writer's block is just alien to me. Because why would you be in a situation where you don't know what you've got to write?

He said, 'I've got a hundred stories on the go on my laptop, and if I ever get any time, then it's just a pleasure to get it out.' And I suppose it made me think about that fear of wasting a day, of being in the studio and not producing anything, or something not working. It isn't always a good thing to have a fear of that. Sometimes you do have to allow yourself to take some risks and make things that don't work. But I think it's how you see your time, and what your time is divvied up into that dictates your practice. Sometimes losing time is good. It can be a good thing and there is something very satisfying about labour.

PB: Time is one of the things I wanted to ask you about. I'm curious about the syntax of a work, whether something is in the present, past or future. You seem to be someone who's very in the present. It's as though the future and the past aren't of any practical use to you, or they don't have an emotional use to you. There may be things that are emotionally charged in the past, but it seems that the act of making for you is *now*. Grab it, and do it!

JD: Yes. I don't really understand what the notion of past would be in making work. And the future, you mean planning something?

PB: No, I mean a quality that's inherent in the work. Objects seem to have an inherent sense of where their time value is, that they can be rooted in a particular tense. The Alberto Giacometti exhibition currently at Tate Modern is filled with examples of what I'm talking about. Sometimes I get irritated with the clichéd romance that surrounds Giacometti which steeps the work in nostalgia and the past. But some of the works are very much in the present tense. The works in the past are burdened with their own weight of history. And others are absolutely vivid, vivid *now* things. And they're often the ones that aren't cast into bronze. Those which are plaster are very in the present.

JD: I think art processes can age your work. You know when you make something quickly, and then it has to become something. Sometimes it works really well. It's a bit of a modern phenomenon, you make it quickly, and then suddenly it's twenty foot high in a plaza somewhere and it's just been taken and recast and reproduced. Sometimes that can work very well, but I think the translation of an idea can be where the ageing sets in.

PB: Also, making something with skill and accuracy can give it a sense of future time. It will endure. It moves into the future tense, rather

be able to define its purpose? I don't think so because I see art as evidence, that someone has been alive, or is alive.

How to be meaningless, isn't there something powerful about eviscerating meaning?

JD: Yes, absolutely. Everyone has the right to look at something and decide what they think has gone into making it. There is nothing worse than someone saying 'oh I understand it' like it's a quiz. There are layers of language that go into art that people digest at their own level. I think that's all you can say about it.

PB: Can you talk me through what you're thinking about for the exhibition at The Fruitmarket Gallery in November?

JD: Yes. Downstairs there will be two main works. A long time ago I started making advice bars (pp.32–37) which were conceived as primarily performative and were part of the social side of my practice that is, especially recently, not always visible in the work. Often in my works there is a place where you can sit or lean, I like that relationship between the objects and the body. I made the first of these bars when I went to New York and I was thinking about the physical reason why a table

can never be used as a bar – it's not high enough to lean on.

I was having classes with Robert Morris who at that point I didn't really know much about, but I was very taken with the way he used exclusion. My art school education in Glasgow had been brilliant and all-consuming – you were embraced by everything: Sam Ainsley, the pub, everything. You were very loved in that department, your work was criticised but it was also valued and the thing that I took from those classes I did with Morris was that he would sometimes simply refuse to critique students' work. I remember there was a woman who had spent a long time making a piece with clothing in it – an art trend at the time. He just said, 'No, I don't critique work with clothing in it' and left. I thought that was brilliant. I mean really brutal, but I liked that idea of whether the work was even worth discussion.

So I created this bar and called it *Advice Bar*, and I would give you a drink in exchange for you telling me a problem. There was no money exchanged and I only served Long Island Iced Teas. The work was a play on my situation in New York as I was working for a psychoanalyst at that point who earned

lots of money and I was also working in a bar where people chat to you, especially in New York where you have that almost confessional relationship with your bartender. I guess even with this I was riffing on the value we attribute to individuals, and the provision of a physical, makeshift place for advice came from how shocked I was by the monetisation of things like education, healthcare and legal advice in the United States. That was so different from the way I grew up in Scotland where these services were provided by the state for all. I remember a group of community activists with a table on Broadway one weekend offering practical advice on money, welfare, health – quite literally a bunch of nurses sitting at a papering table in the street saying – how can we help? And it was so busy. It was a very vivid first impression of living in the US – that there was no safety net.

So for the Fruitmarket I want to make a new advice bar, but it seems relevant, now, to make it much bigger. I want it to invade the gallery spaces, so it's going to be a really long bar that is still like the original, in that it is a table with two legs, propped up to make it the right height. But this time it will be made out of concrete and will cut through the wall between the two ground floor spaces, looking a bit too big and brutal, invading the gallery; an object expressing the way things feel at the moment. It's called *Advice Bar (Expanded for the Times)* – a nod to everything that's happening in politics here, and how closely it's mirroring disturbing times in the US.

Alongside it, I'm going to show one of the trailer pieces called *Temple of Jackie* (pp.192–93). It's a big object based on a camping trailer which looks precarious standing up on its little legs. A bit like the *Advice Bar*, it's a big sculptural object with the potential for things to happen in and around it.

PB: It looks almost like a market stall.

JD: A bit. It has this cantilevered shape that I love. I've drawn it a lot. Before I make the trailer works I draw them. I do quite a lot of these drawings. I like things that fold and move, and open out. I like it if you have a thing that can become something else. I enjoy that in work. I think this suits what I want: a substantial solid thing that has a history of use for something and is oddly shaped.

Upstairs there will be a series of lines, like the drawn lines that I've done before in chalk attached to bikes in *Huntly Slow Down* (pp.159–

65); or the fluorescent zig zag line that ran up a hill in Bellahouston Park (pp.185–91); or the orange lines like railings I made for the Gallery of Modern Art, Glasgow (pp.248–49, 252-53, 256–57). These last two are sculptures but I do see them as drawings. I'm going to make one as a big sweeping line, probably bright green. A really strong brightly coloured line that's going through the upper gallery and right down into the stairwell onto that big white wall, hooking into the building itself.

Another new work that I have just finished is a leather paper chain titled *An Era of Small Pleasures* (pp.8–9).

PB: I respond strongly to the contradictions of the leather paper chain. Its origin lies in ephemerality – materially, temporally and in terms of weight – and it has been transformed into something permanent: paper into leather, enduring, heavy … it is magical.

JD: It works as another line going across the space that will droop and sag between the steel beams in the roof. It's very long and I want to hang it across the gallery and let it end in a pile on the floor. The loops are similar in scale to paper chains and how it was made is important, that it references something that you tend to

make in your home – which in part comes out of my horror of the studio I suppose.

PB: I think it's got something almost sexual about it in some way. When you look at the work, not formally but as a sentient thing, there is something provocatively erotic about it. The leather. I like that edge between the formal and the very serious side of art historical legacy when it starts to break free of that, the object almost answering back.

JD: One of my *Winter Trees* sculptures (pp.140–141, 144) bends and has leather around it. I always see these works as being defiant – I see them as portraits of my sister and I in the early 1980s. There was a real defiance over what we wore: wearing leather was frowned upon. It was associated with fetishism and bikers then but it's become much more commonplace now. I've not used leather that much but it seemed appropriate for these works.

PB: I've always found those dance poles interesting. I was listening to a programme on the BBC this week, part of their 'Gay Britannia' season and there was an online sex worker on the radio describing the pole as a stage object that the client can fantasise about without it having to be used. The way she talked

about it so powerfully eroticised this perfectly ordinary vertical piece of metal.

JD: That potential for use.

PB: Is that a thing that interests you – letting an object go? An object finding its own potential beyond your control?

JD: Definitely. It's something that *An Era of Small Pleasures* does; it's not an object until it is hung up. Like a pile of string, it needs to be attached to something to take a shape.

PB: The leather and the surface and even the clip that holds the links together make it an object in transition. It has departed from the paper chain and I don't know what it is going to become, but I do know that it is incredibly heavy. The transformation from something light and disposable to something heavy and impractical is a powerful subject in itself.

JD: It's prevalent throughout my newer work, the idea of something being the same but different. Something that has the same characteristics as something that you are familiar with that has connotations of fun or the social activity of children making them (you always make paper chains collectively don't you?) becoming something heavier, hard to hang and hard to make. It has the same form but it is not that thing.

PB Remaking the world we live in could be seen as utterly pointless but it is a new declaration of what an object is and what it does in our lives. I'm interested in exploiting the potential aggression of seemingly harmless things. The act of remaking them makes the object angry.

JD: Angry and threatening.

PB: Exactly. It has qualities which are at complete odds with the status of the original. The fake copy is a form of performance for me.

JD: And usually with fakes and copies you get a version which is made out of inferior materials and has had less attention paid to it, so there is something perverse about spending so much time making something that's flimsy and whimsical into a very solid object.

PB: And using materials which transform that simple object into an extremely difficult one, this is something that is often incredibly difficult to explain.

Permanent public work: powder-coated steel tubing, clamps

The runners of the park go in groups, running along dark streets and quiet avenues.

Sometimes they pass.

Everyone nods and smiles.

There's a route where we cross the river twice, gently connecting south side suburbia with inner city floodlighting, these women in woolly hats and DayGlo vests quietly padding past the waterside developments.

The BBC glows purple and green to complement us. On the return loop we pass the beginners group, lumbering breathlessly along the road, shiny new jackets tied around waists. Everyone gradually returns to the sports centre car park, red cheeked and breathless but happy with the night's work. A quick chat then dispersal and home. Dinner waiting, work done for the day, the Wednesday night feeling is a good one.

These are the dark winter runs skirting the edge of the park on well lit roads; in spring and summer its hills and sweeping drives see flashes of lycra through the trees, mixing with the children playing, walkers and dogs.

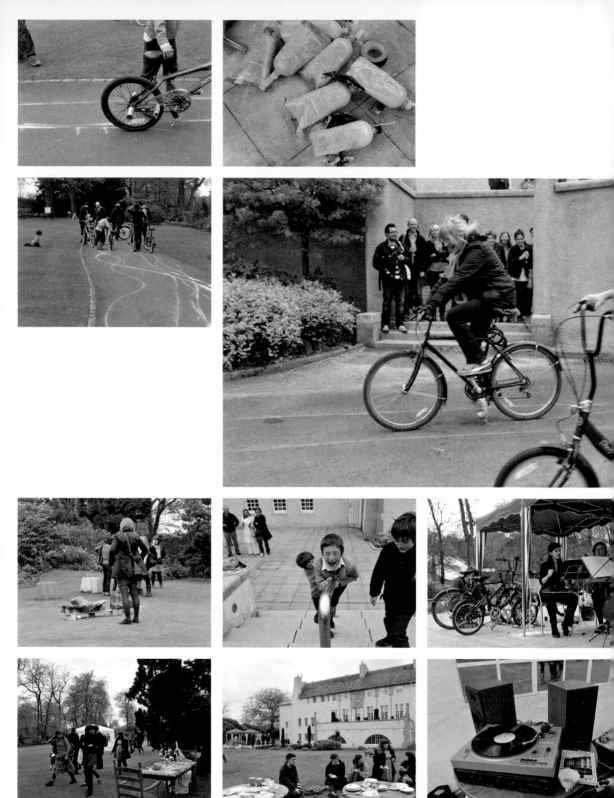

Speedwork Spectacular, day long live event with Glasgow School
of Art Sculpture and Environmental Art students

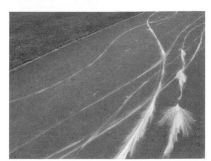

TEMPLE OF JACKIE 2011

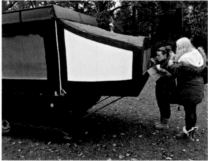

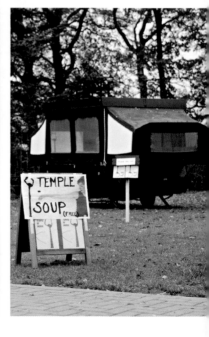

Installation and live event: adapted trailer tent, plywood,
video, sign, light, drawings, newspaper edition
Radar, Loughborough University Arts

THE SUNNIEST PERSON I KNOW 2012

The Sunniest Person I Know, 2012
Two screen digital film with original music by Peter Baynes, 3 minutes, looped
Going Viral, Glasgow Science Centre

194

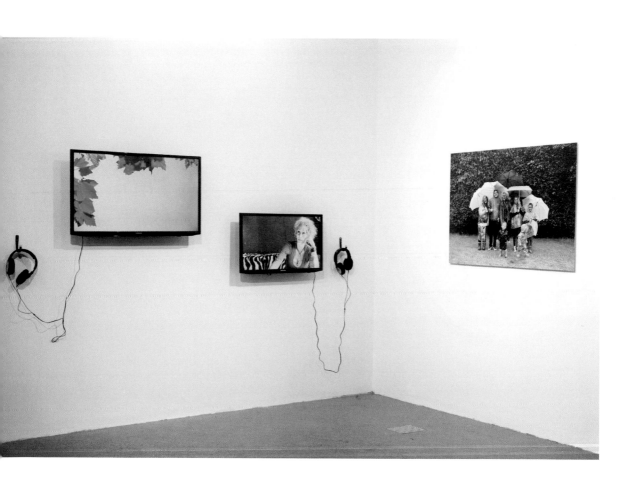

The sunniest person I know used to live on my street. I'd see her walking with a pram, tanned, blonde, smiling, followed by a gaggle of curly blond children. I'd meet her in the supermarket where we all bought cheap fruit and vegetables, see her at playgroup, take turns with the pick-ups when our kids went to school together.

A few years ago she was diagnosed with multiple sclerosis, a final explanation after years of feeling 'not quite right' that led her to examine many aspects of her and her family's lives; she is very close to her four children and two young grandchildren, and there is clearly a strong family bond, both physical and emotional, that they all share.

Like many patients, Kirsten has strong views about her illness that cannot yet be answered by science alone but, like many, also has great hopes for what the future could bring.

'I don't feel that this is a physical disease, I think it's much deeper than that. It's like not being loved, not being cared, you don't have that defence (for your immune system), there's something there that just doesn't work.'

Kirsten Moore and family, Midsummer's Day, Glasgow
Digital photographic print mounted on aluminium, 110 x 70cm

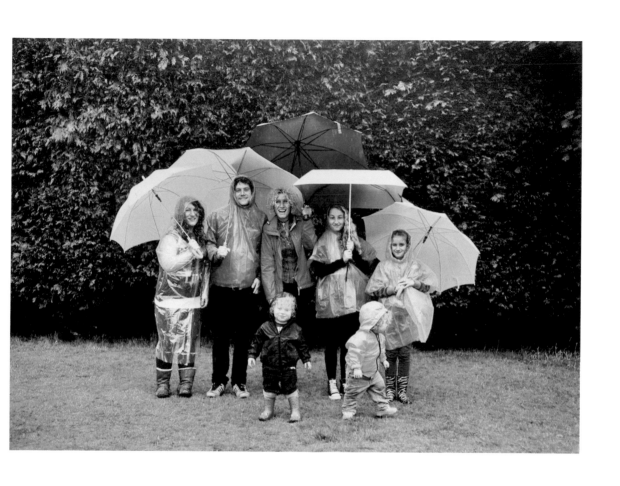

above: *Shed* (detail), 2013, drawing on lacquered plywood, 39.5 x 121cm
opposite: Installation view with *Winter Trees II*, 2013, aluminium tubing, cotton, plastic,
spray paint, dimensions variable, Patricia Fleming Projects, Glasgow
following: *Glimmer V, Glimmer II,* 2016, pencil on paper, 100 x 190cm

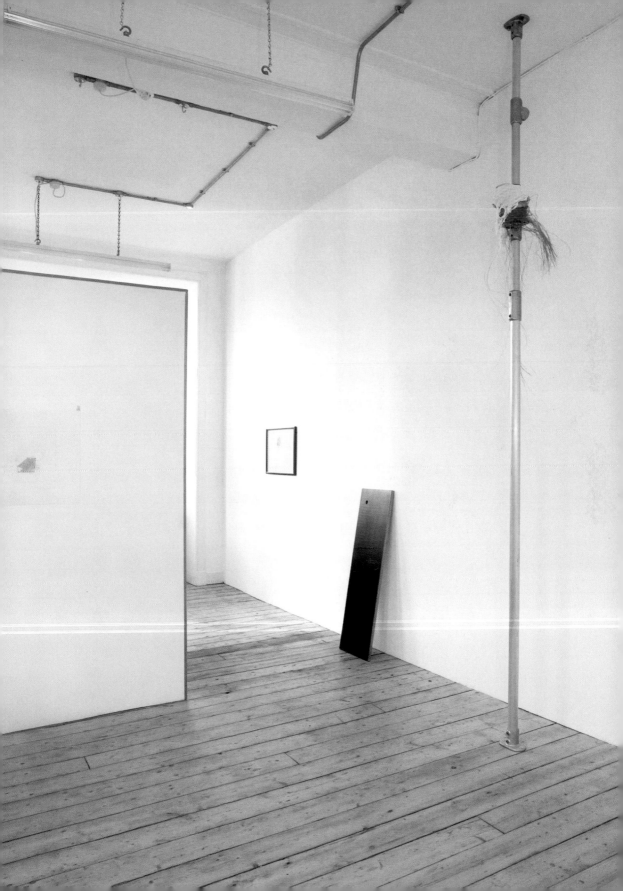

Parson Heights, 2013
Pencil on mapping paper, 29.7 x 42cm
Fountainwell Handrail, 2013
Pencil on mapping paper, 29.7 x 42cm

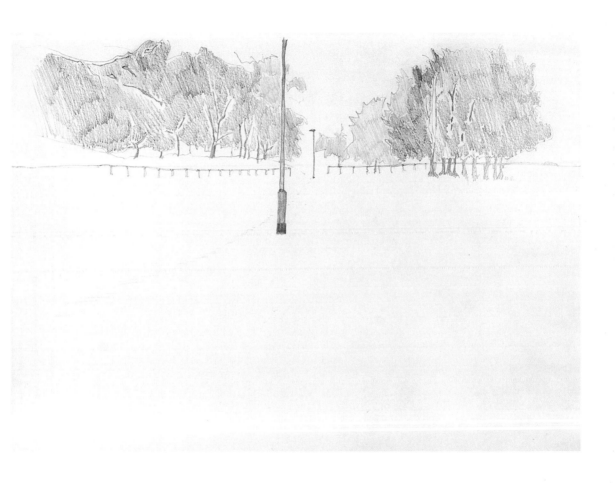

COMMUNITY CENTRE 2013

A return to etching after a very long absence seemed a natural progression from a recent period of drawing with pencil on paper, and making sculptures with metal. The etching is called Community Centre and is a simple drawing of a 5-a-side goal net. It gathers together my thinking around space and relationships, art and community. The net, like so many seen in public parks and sports centres, provides both the focus of a game, and a place to be; the place where jumpers and phones are left as youths play, an object that transforms an open space into a site of activity, a site which requires either participation or spectatorship. Thus it is an image that provides a reference to gathering. The site of this gathering doesn't need to be a football pitch or public park though, it can be any location where people connect (the football reference is one that comes easily to me currently, but my experience of working in bars gives another example). In this reference to gathering and community, and the construction of sculptures of metal and thread, and the drawings of lines on paper or etchings made of lines in metal then printed onto paper, many reflective of disability and loss, there lies the connection to a body of work which has also undertaken public events and performance. There's a gap there though, and I think that that gap is very much filled with the notion of 'participation'. And I think that 'participation' and 'communication' are some of the big things that can maybe get carers through terrible times.

Etching on Somerset Satin, 75 x 63cm (framed)
Edition of 10

MELBOURNE SLOW DOWN 2013

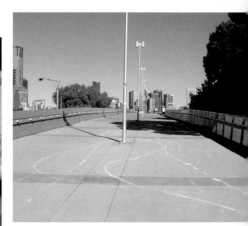

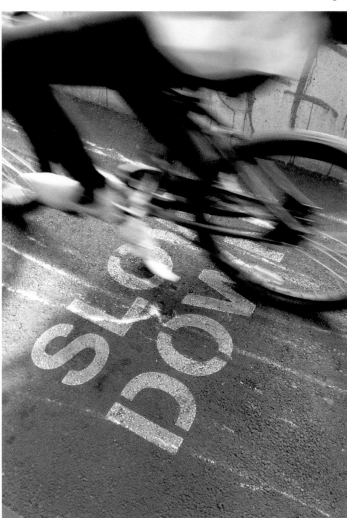

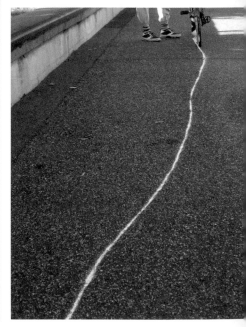

Mass bike ride in four parts from the outskirts of the city to the centre:
100 cyclists, powdered chalk and handmade chalk dispenser
Australian Centre for Contemporary Art (ACCA), Melbourne

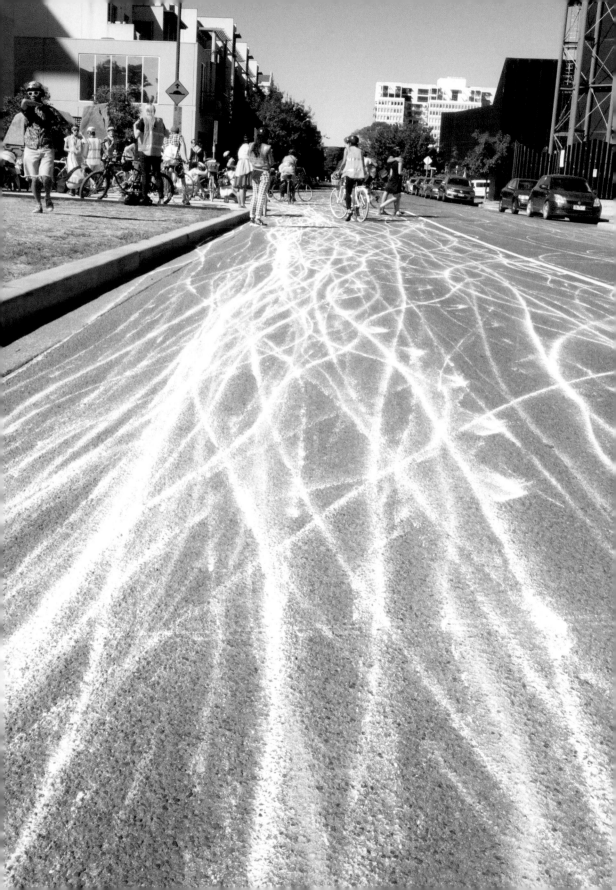

MARY AND ELIZABETH 2014

Mary and Elizabeth reflects on the relationship between two sites, two cousins, two countries, a new king and an old alliance. I see a timely link between these sites, a connection fuelled by knowledge, lore and literature that loops from popular novels of scandal and sentiment ('Waverley', by Sir Walter Scott was first published 200 years ago this summer, in July 1814) to historic conspiracy and bloodshed, all connecting through a national debate around democracy, identity and governance.

Waverley joins Edinburgh to London, literature to romance, London Society to Scots rebellion, Victorian society tartan to Jacobean velvet … James was a young King who connected two countries, after a childhood which saw his beautiful mother imprisoned then executed by his fearsome, pock marked aunt. New St Andrews House was where government decision was implemented in Scotland from the 1960s till the 1990s, an outpost in the north to a parliament far away, that now sits gloomily empty awaiting demolition.

Connecting all of this is a red, red line in my mind. All that anger, blood and turmoil - racing up the stairs of Waverley and out onto Princes Street, over the road and into a brutal grey world, hidden from Edinburgh society by chicken wire and smoked glass.

Installation with live event: powder-coated aluminium,
steel, satin cord, red powdered chalk, cyclist
Edinburgh Art Festival

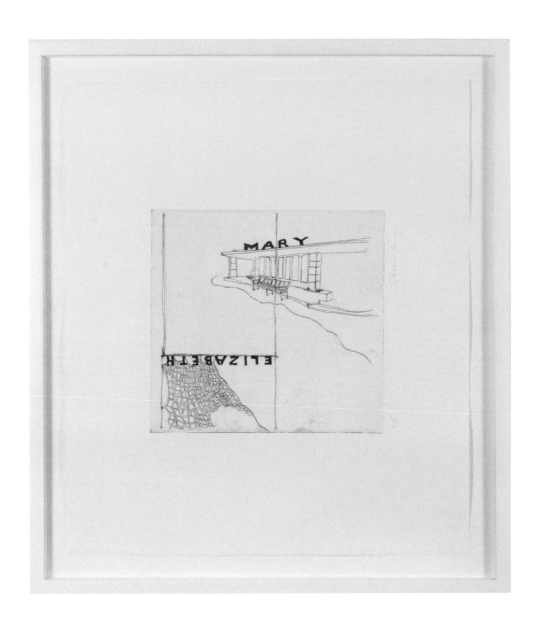

Mary and Elizabeth, 2014, etching, 44 x 38cm
Edition of 50

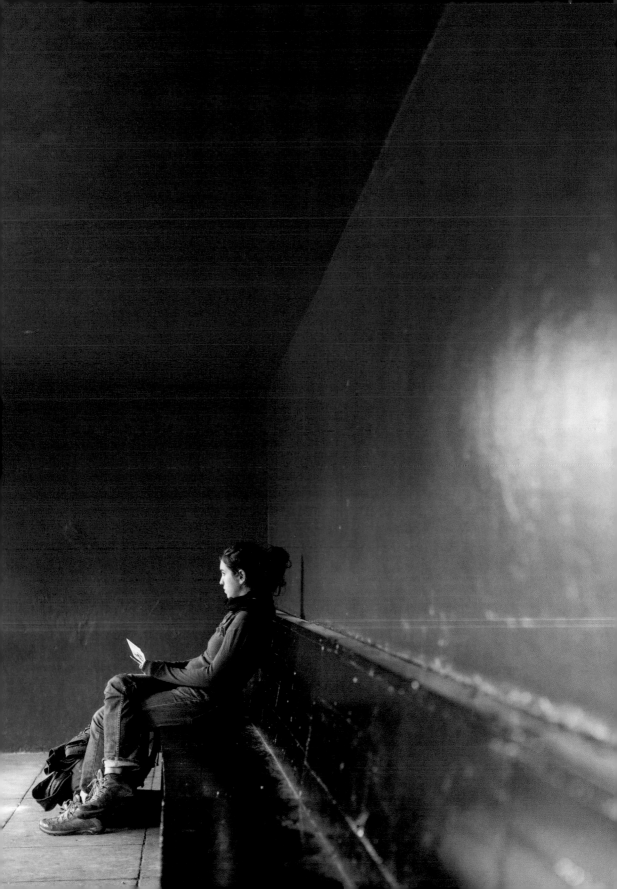

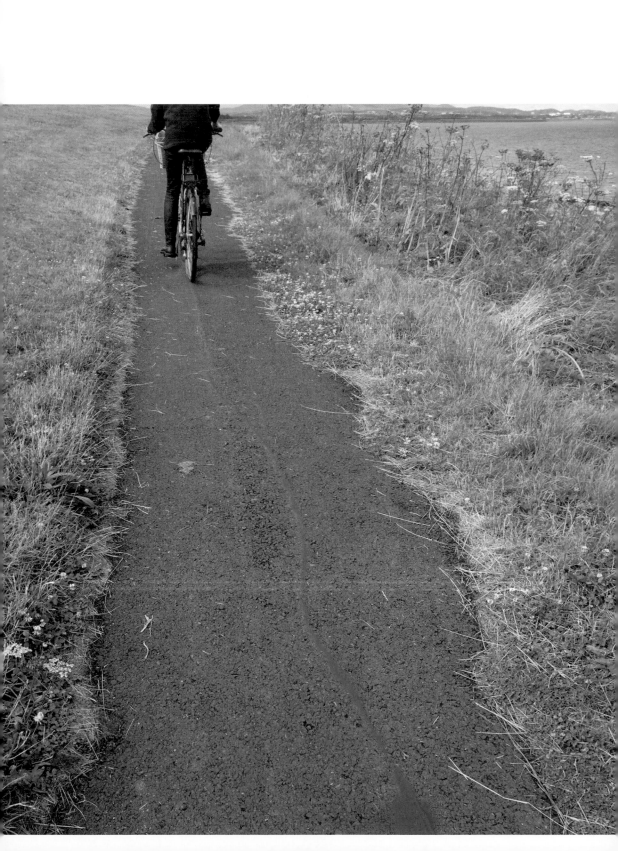

GLASGOW SLOW DOWN 2014

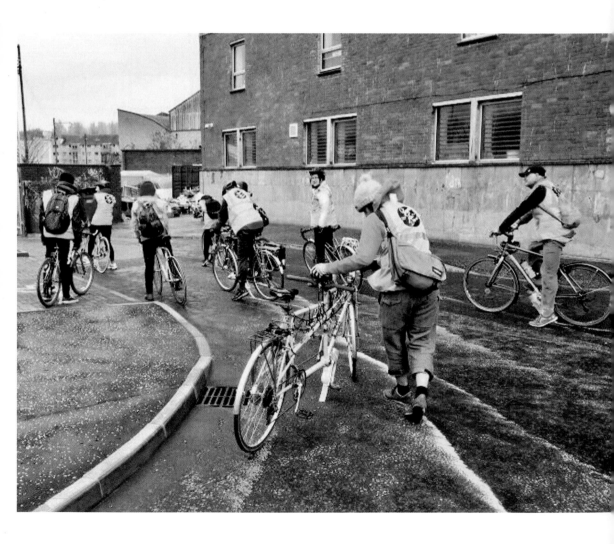

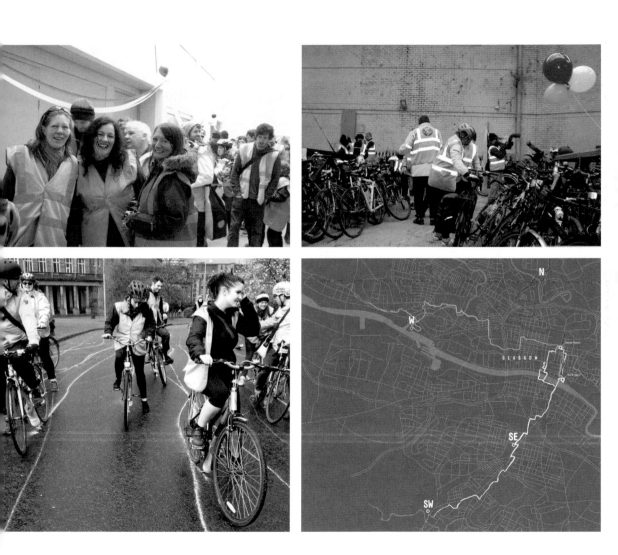

Mass bike ride in four parts from the outskirts of the city to the centre:
100 cyclists, powdered chalk and handmade chalk dispenser
Commissioned by Velocity as part of the the Glasgow 2014 Cultural Programme
of the XX Commonwealth Games

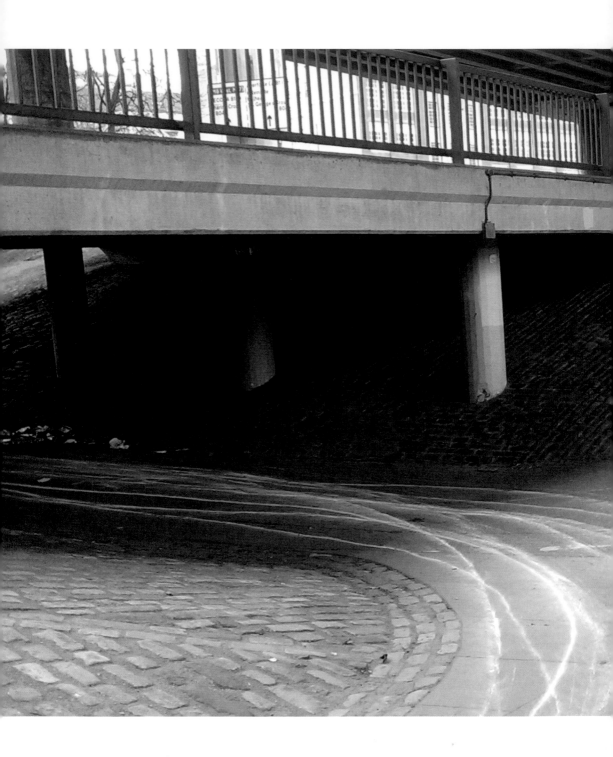

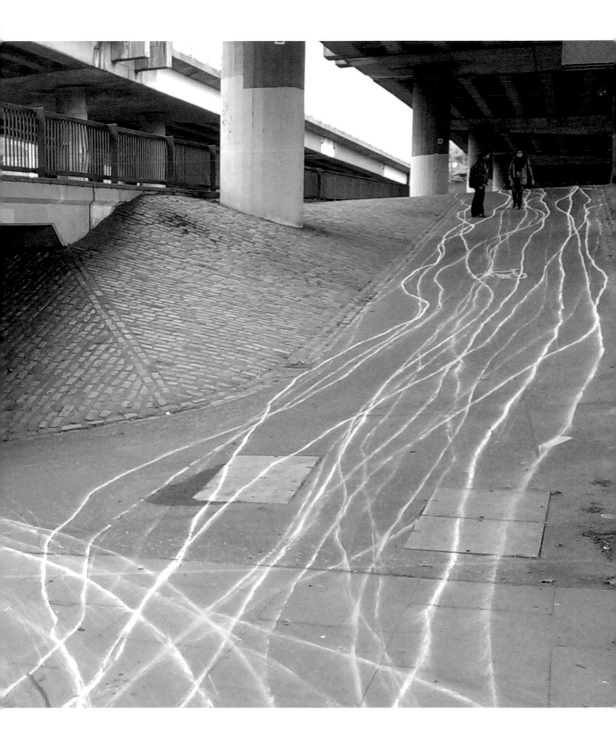

DEEP IN THE HEART OF
YOUR BRAIN IS A LEVER

2014

A sculpture made of powder-coated,
textured matt black aluminium. Cold and
hard to the touch, but sleekly beautiful,
the work is strong but not solid. Large
enough to support several people,
standing or sitting, it is hollow, with
a mesh side panel that allows a peek
into the darkness underneath. The ramp
is hinged, and is therefore possible to
lift, given enough strength.

It was shown first in Leamington Spa Art
Gallery and Museum which are housed in
the town's former spa building, with the
local municipal library also located on
the site, built within a redevelopment
of the former swimming pool. The museum
shows the history of the town as a centre
for therapeutic treatment, with many
items such as pulleys and harnesses from
its past use on display.

What struck me on my research visits was
the poignant testimony of a mother who
used to bring her young children to the
pool in the 1980s; her son had cerebral
palsy, and she brought him and her other unaffected child to swim
once a week after school. Both children loved the atmosphere there,
her son benefitting from the therapeutic service available to him,
mother and daughter relishing fun swimming time together whilst this
took place. She spoke of how safe they all felt at these times, and
how much they looked forward to them as a family. So, what I wondered
more than anything else was where did they go when this place closed

Powder-coated aluminium, 443 x 200 x 45cm
Leamington Spa Art Gallery and Museum

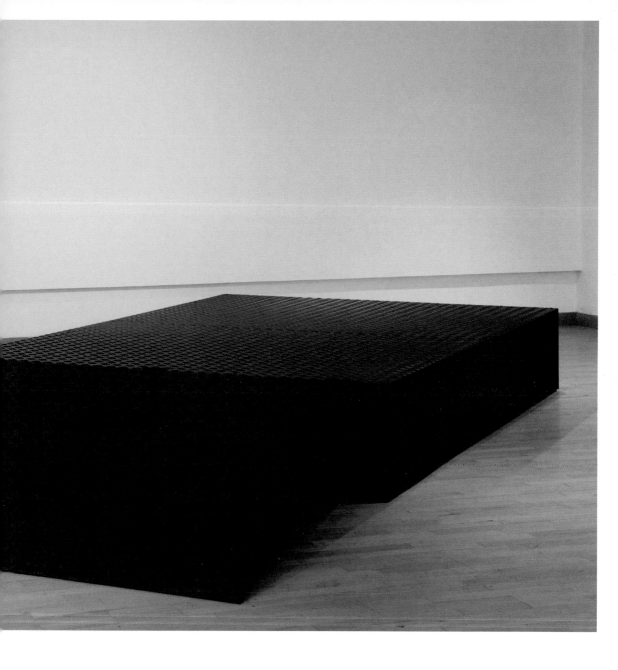

in 1989? Was there a beautiful new therapy centre and pool available in the town? Or had the service been removed entirely to be replaced with a cultural display? My exhibition, or that of anyone else, was surely no substitute for this experience. And so the placing of a substantial dark object, a black hole one could say, in the centre of the exhibition space became a response to that, in as much as it could be a response to anything. In a small local museum that was once a therapeutic swimming pool, what can a static metal sculpture invoke other than loss?

The title of this piece is taken from a Patti Smith lyric which, synonymous with chaos, has always spoken to me of care.

Indoors, mid-morning, no one dressed. Lunch club cancelled.

A supermarket car park, an elderly woman struggling to fold a wheelchair into a car.

On a train with a teenager rhythmically banging his head on the window.

A woman trying to lift a fallen woman.

Steering an elderly man away from the bar at a funeral breakfast as he begins to vomit red wine gently into a handkerchief, the wine all he has consumed in two days.

Many factors dictate if these are or are not commonplace events in common places, a daily occurrence, or a dark, isolated moment that asks much of a person. This work invokes the inner strength that is required to get your husband out of the house and into a car, or your adolescent, autistic son to bed, something that must be done over and over, again and again. Ordinary, unglamorous, and with no medal. A lever in your brain that at times you must apply.

Keep Up, 2014, aluminium tubing, satin cord, dimensions variable
Lampposts, Glasgow, 2014, pencil on cartridge paper, 6 x 1.5m
Winter Trees II, 2013, aluminium tubing, cotton, plastic, spray paint, dimensions variable

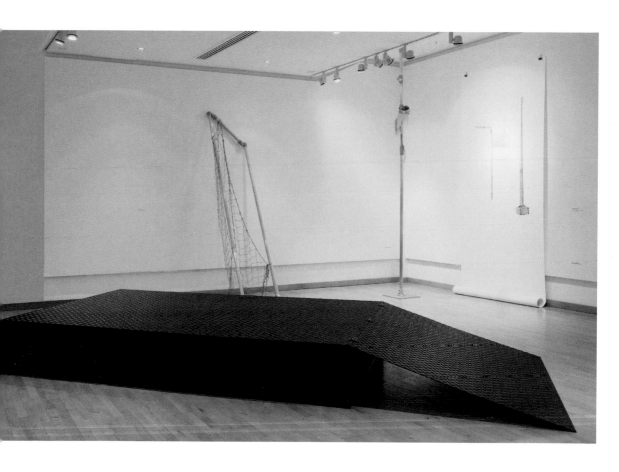

Film Stills (Elizabeth), 2014
Giclée prints, 29 x 35cm each

NEW WEATHER
COMING 2014

The research process for 'New Weather
Coming' included, early in the year,
a week-long journey through Scotland
using public transport, a solo trip that
began with a single flight to Lerwick
in Shetland, and ended when I reached
home, just outside Glasgow, seven days
later. I journeyed down and across the
country on trains, boats and buses, with
no exact plan other than to visit new or
long-forgotten places on routes mapped
out each day. Oysters in Oban, the
Kyle of Lochalsh train from Inverness,
the Armadale ferry. Destinations were
mainly holiday places, nothing remote
or undiscovered, very much influenced
by summer travels from my childhood
when, as my parents did not drive, all
journeys began at the local bus stop or
train station.

Three itinerant mobile sculptures, artist's book distributed
on holiday routes in Scotland over summer 2014
Powder-coated aluminium, trailers, artist's book
GENERATION 25 Years of Contemporary Art in Scotland

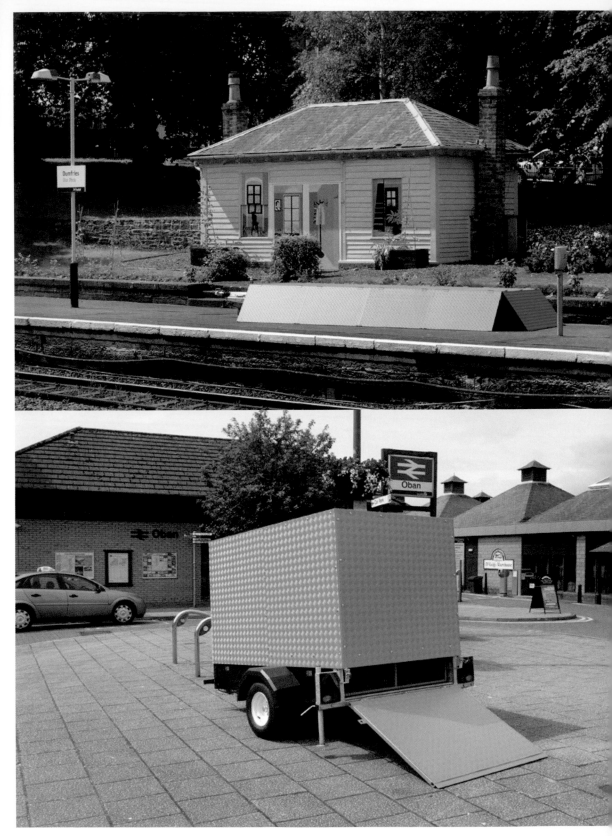

Your mind can wander on these trips. No computer or phone was a rule, so I took notes and read books, watching from the back of the carriage as we went from one terminus to the next. The journey thus provided a very focused time of observation. I watched a lot of travellers move on and off trains, I queued with many, helped others with bags, luggage, shopping and at times had to seek assistance myself. Regular journeying experiences, heightened by being alone and tasked with a notepad and camera to both 'document' and 'research'.

I noticed families like my own, filling a day on a train. Busy chattering people, quiet slow people. Children. Sandwiches. Avoiding commuter routes and commuter times, I encountered the more wistful travellers, noted relationships unfold and occasionally unravel, on journeys so different in intent and expectation than those taken by commuters. The trip resulted first in a new artist's book, distributed over the course of summer 2014 on various transport routes around the country, and a family of three itinerant mobile sculptures placed at points on these routes throughout the summer, points where travellers change from one kind of transport to another, such as boat to train, or train to bus.

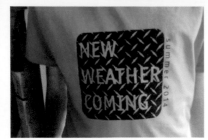

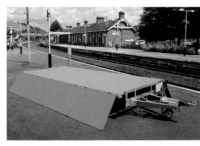

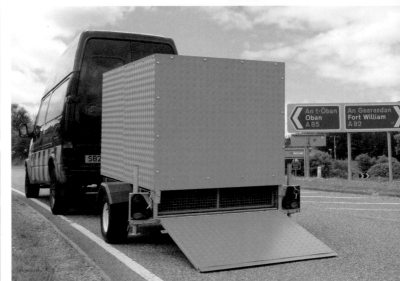

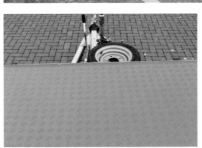

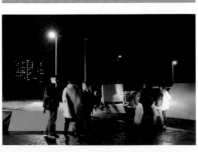

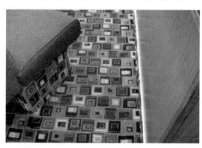

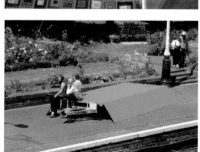

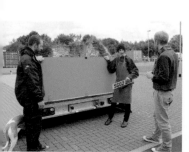

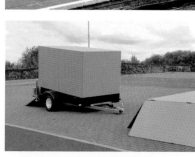

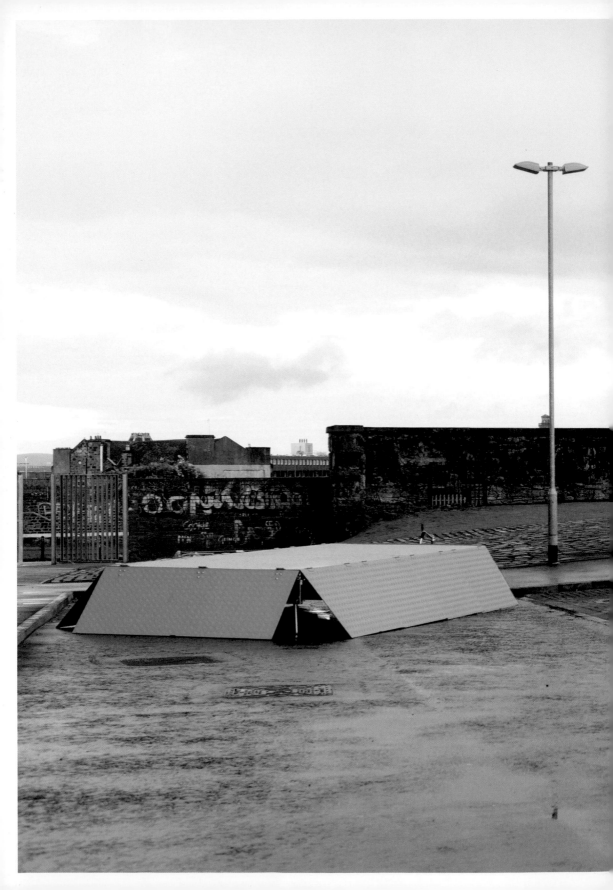

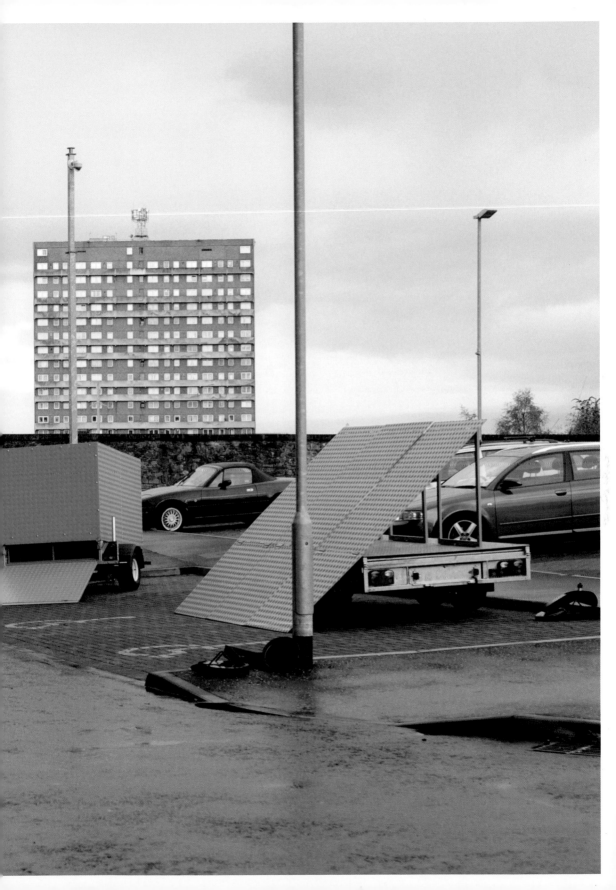

SOUTH (OSLO) 2015

Permanent public work: heated concrete disc, 8m diameter
Aker Brygge, Oslo

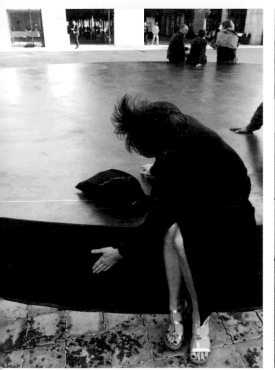

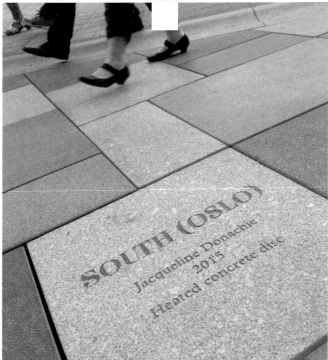

SOUTH (OSLO)
Jacqueline Donachie
2015
Heated concrete disc

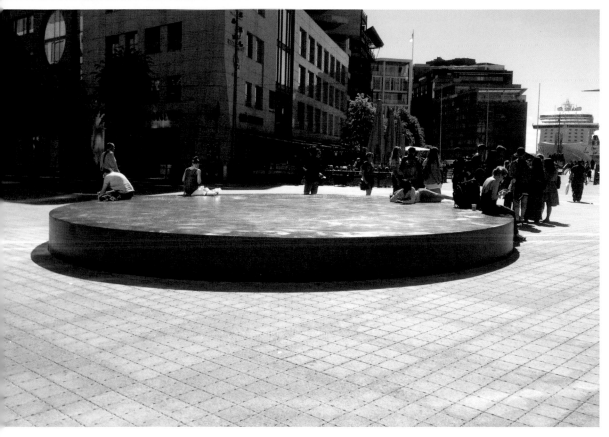

POSE WORK FOR SISTERS 2016

The concept came from consideration of the work of
Bruce McLean - a hunch that I should look again
at his early photographic and performance work
including 'Pose Work for Plinths' (1971). McLean's
work is often seen as ironic, however it is both his
sharp sense of art being 'in the world at large' and
his perceptive use of performance, props and staging
that are relevant here. It connects in ways that are
complex, various and essentially unpredictable, the
natural and the social aspects of human existence.

I find the use of both the term and the action
of posing, employed throughout McLean's practice,
compelling, and this key work from the 1970s provides
a clear exemplar. In one sense it is a peculiarly
Glaswegian understanding of the word that cleaves
directly to one particular dictionary definition of
pose: to 'behave affectedly in order to impress
others'; in another it is an allusion to Erving
Goffman, and his description of 'performance in the
everyday world of social interaction' that is also
explored in Mel Gooding's description of McLean's
band Nice Style.

The staged format of the original photograph and its
playful, spirited images of a young man awkwardly

Digital video (no sound), 10:01 minutes, looped

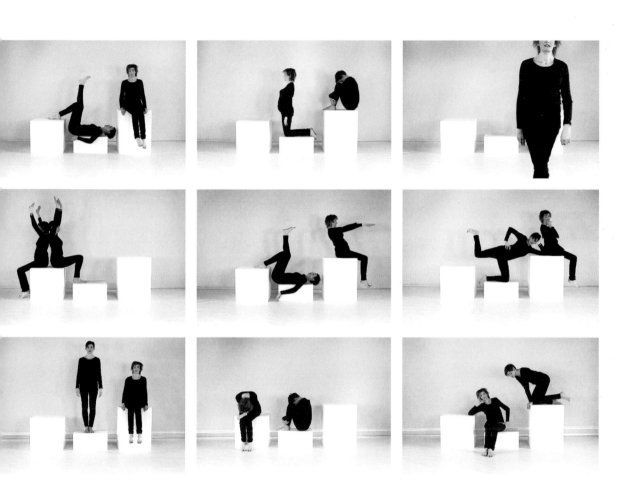

posing, mimicking statue shapes in a staged setting
(on white plinths against a white background)
brought to mind an early set of photographs taken
with my sister Susan, when she was pregnant with
her first child in 1995. This was well before any
diagnosis of genetic illness, and at a time when
I was producing a number of staged, studio-style
portraits of myself that were exhibited in diptych
form, each with a short written piece. The decision
to capture a moment when our physical similarity
began to separate (due to her expanding size) was at
that time purely opportunistic, as it sat well with a
number of portrait/text works I had been producing,
and struck me as an appropriate moment for a wry,
humorous text. The value of them as a recording
of a significant point before our knowledge began
was only to arise as I embarked on this research
years later, and considered how best to present
our (again) differing physicality in terms of an
illumination of loss.

As it is mainly in movement, and not physical shape,
that we now differ, film was an appropriate medium
for this piece, and a studio session was organised
with three plinths and a white backdrop. I asked
Susan to dress in black (as McLean had done in the

original), though beyond that the action was very simply choreographed: walk into the frame, sit/stand on the plinth, hold the pose for around 5 seconds, stand up, walk out of the frame. I decided against studio lighting, and so we also had to work quickly to make best use of daylight; it was a spontaneous, uncomplicated session measured mainly by what Susan could and could not physically manage. Each pose was photographed as well as filmed, but it was the moving image footage of us walking in and out of the frame and holding a series of bizarre and impromptu positions that was the most compelling. The setting of plinths against a white background and the grid of multiple poses a deliberate reference to McLean, and the looped repetition of the piece rendering a simple, rhythmic rise and fall to the work that offers an additional portrait of both similarity and loss to that seen in 'Hazel'. Two tall, slim middle-aged women wearing black, walking, sitting and standing. Posing. When static, little separates us, but in moving on and off the plinths there are subtle differences in gait, posture and ability that speak of inheritance in many forms. It brings to mind the opening line of DM: 'All my life I've been told how much I look like my sister.'

HAZEL 2015

HD video, 8 minutes
Premiere screening at the International Myotonic Dystrophy Consortium Meeting,
Paris, 2015

My intention was to show pairs
of women who are the same,
but different. To create
a portrait of loss. Where
is the tipping point when
someone stops looking like
their family and begins to
look like their disability?
Using my own terms my sister
and I look like each other,
but my sister also looks
like an illness.

above and following: *Hazel*, 2015, three channel audio video installation, 9:48 minutes

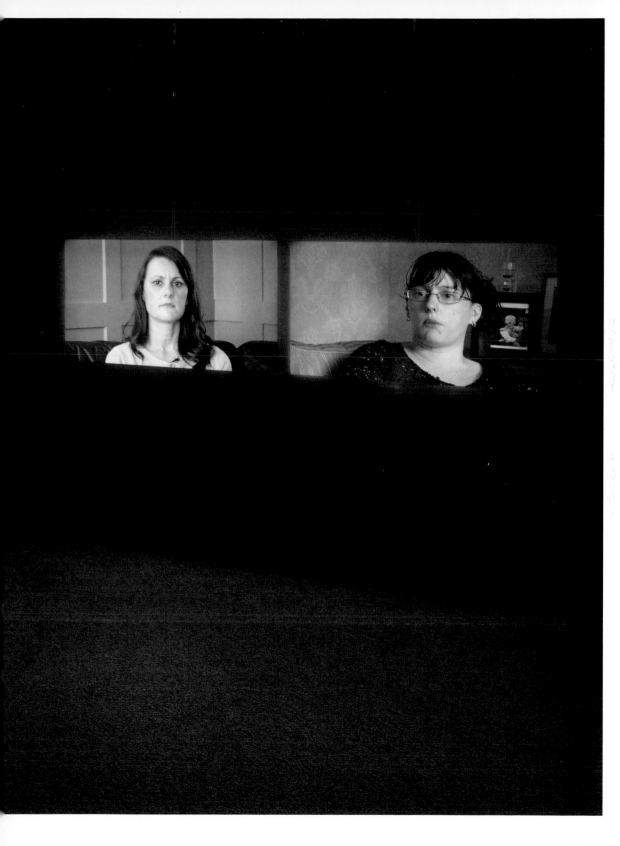

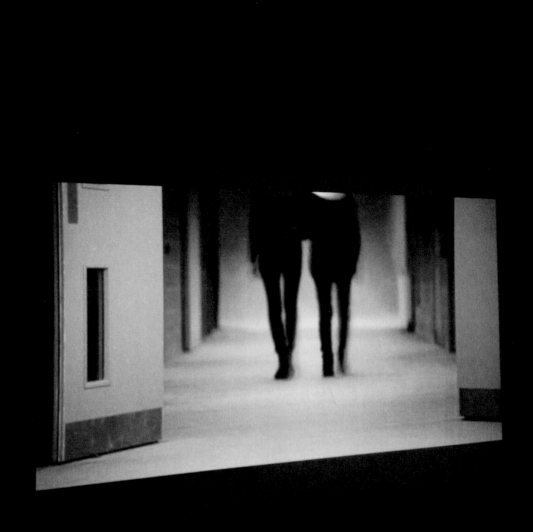

DEEP IN THE HEART OF YOUR BRAIN 2016

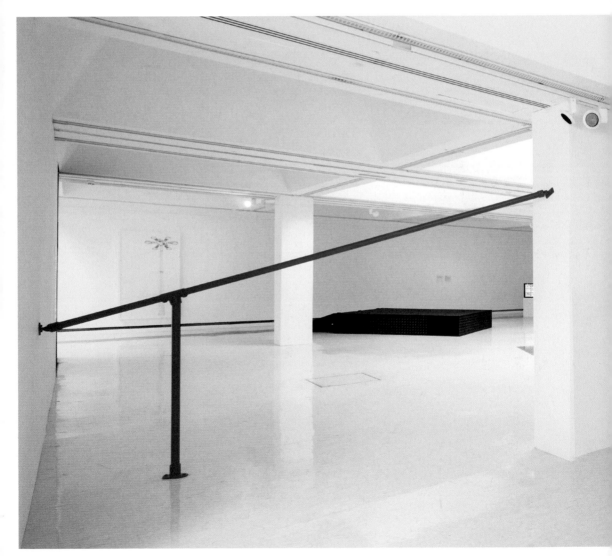

Nice Style, 2016, powder-coated aluminium, 18 x 0.4m
Gallery of Modern Art, Glasgow

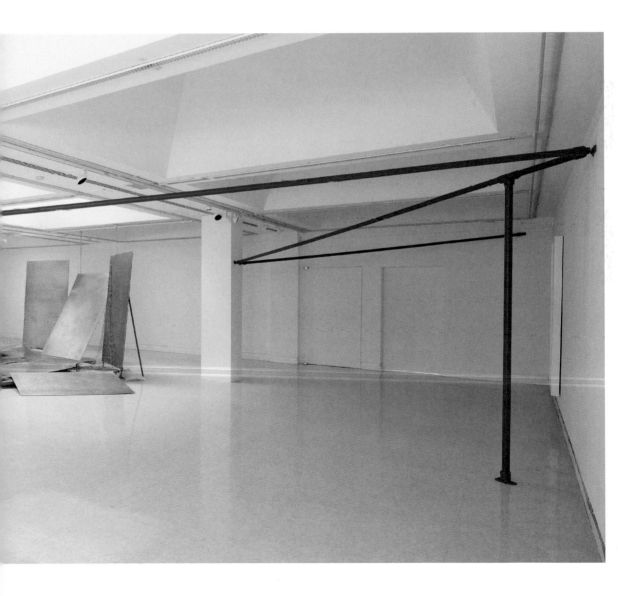

Deep in the Heart of Your Brain is a Lever, 2016
Powder-coated aluminium, 443 x 200 x 45cm
Pose Work for Sisters, 2016
Digital video (no sound), 10:01 minutes, looped
Studio, 1995, 2016
Digital print on Hahnemühle Photo Rag, 110 x 180cm

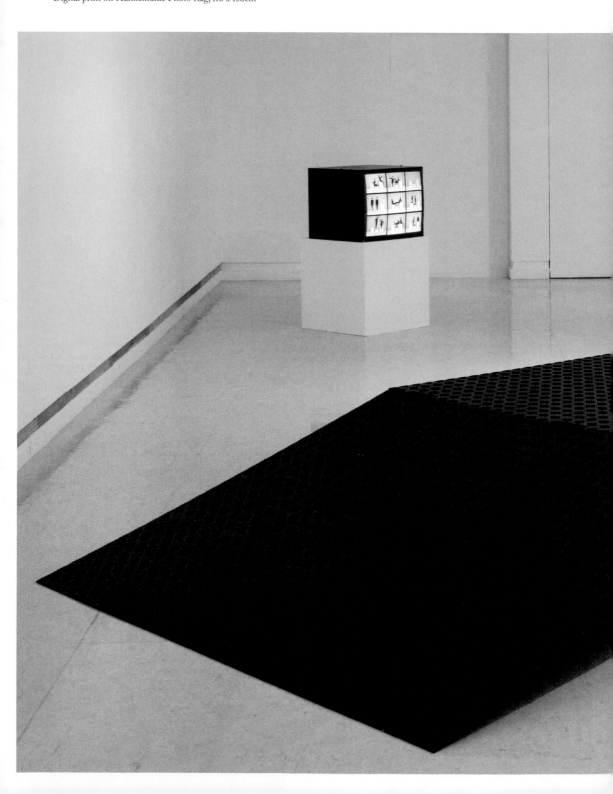

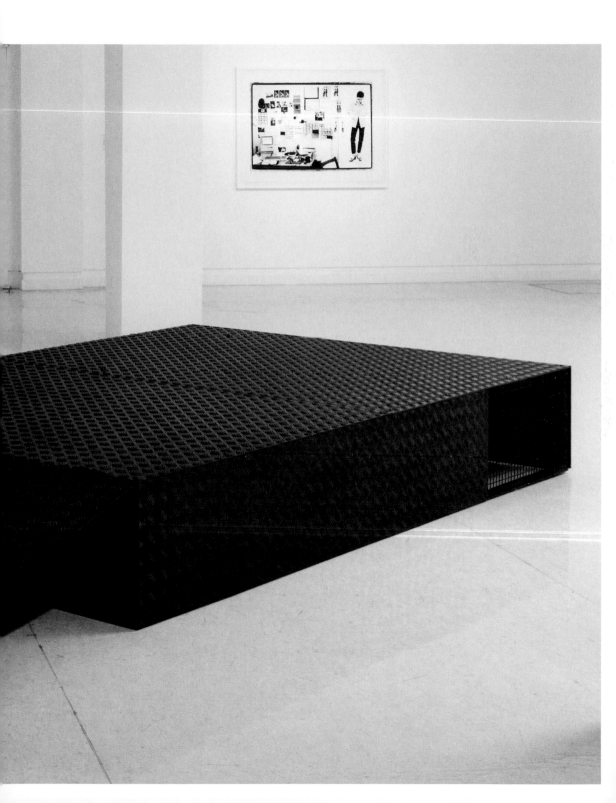

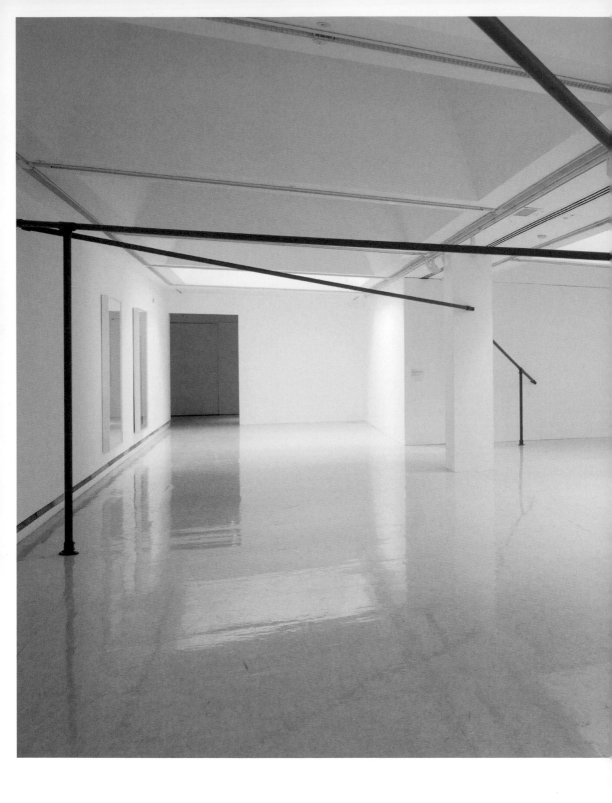

Headphone Music, Boats and Trains, 2016
Aluminium sheeting, steel frame, plywood, road paint, satin cord, sandbags, 4.3 x 5.2 x 2m

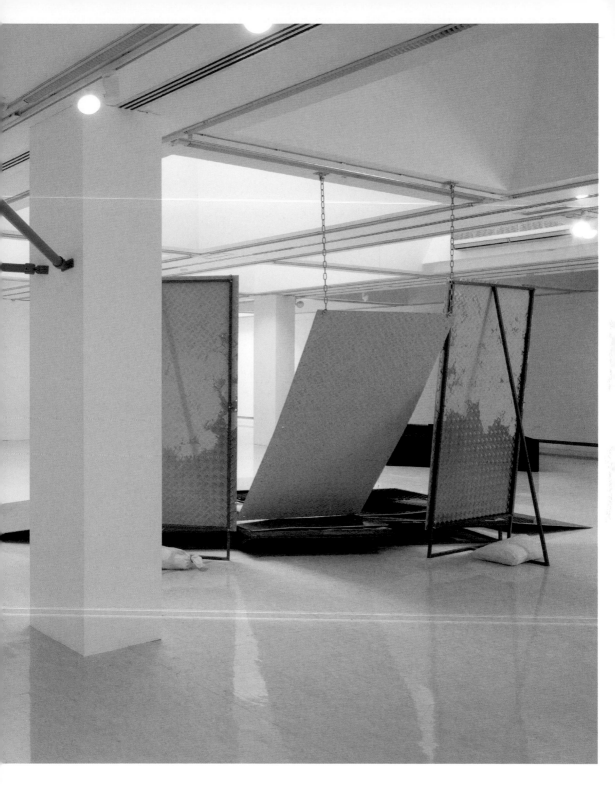

Glimmer III, 2016, pencil on paper, 100 x 190cm
Winter Trees V, 2016, aluminium tubing, rope, wool, string, 350 x 10cm

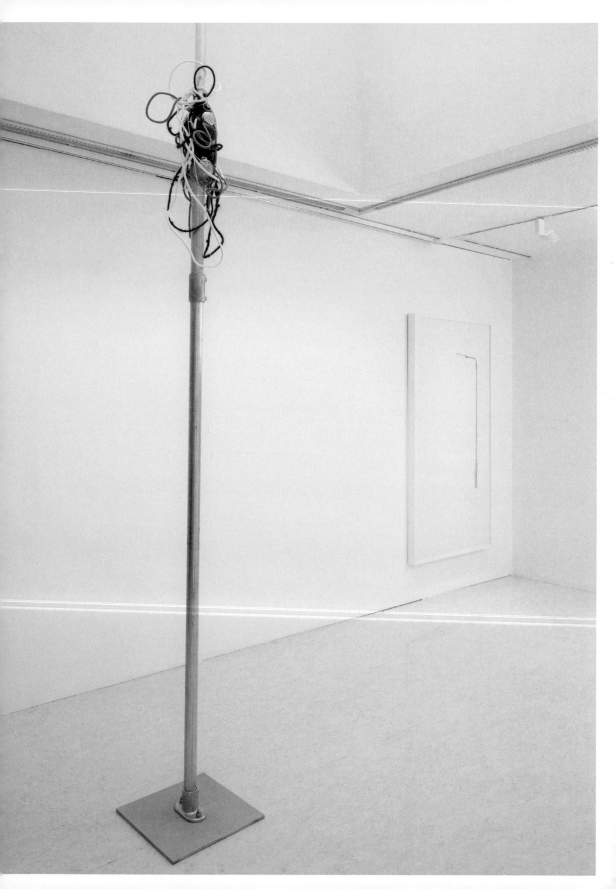

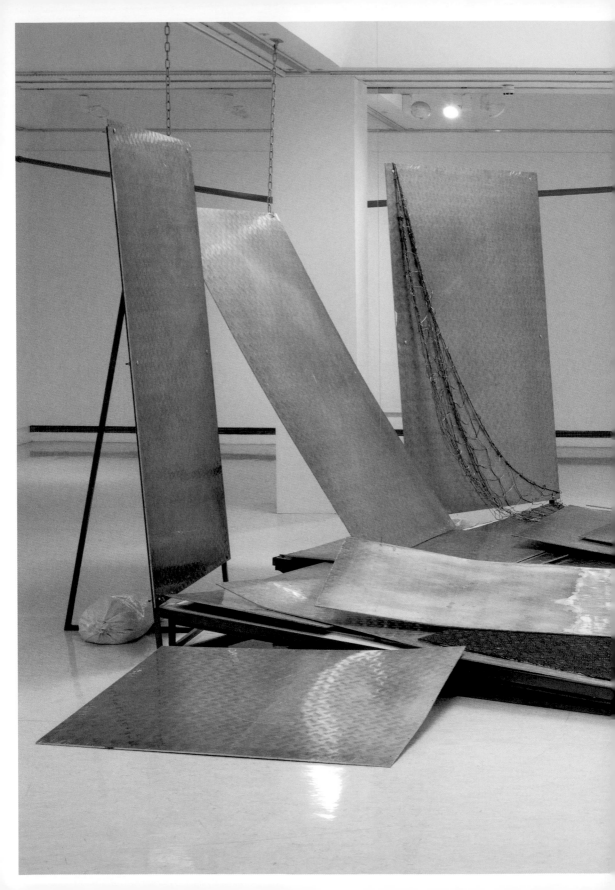

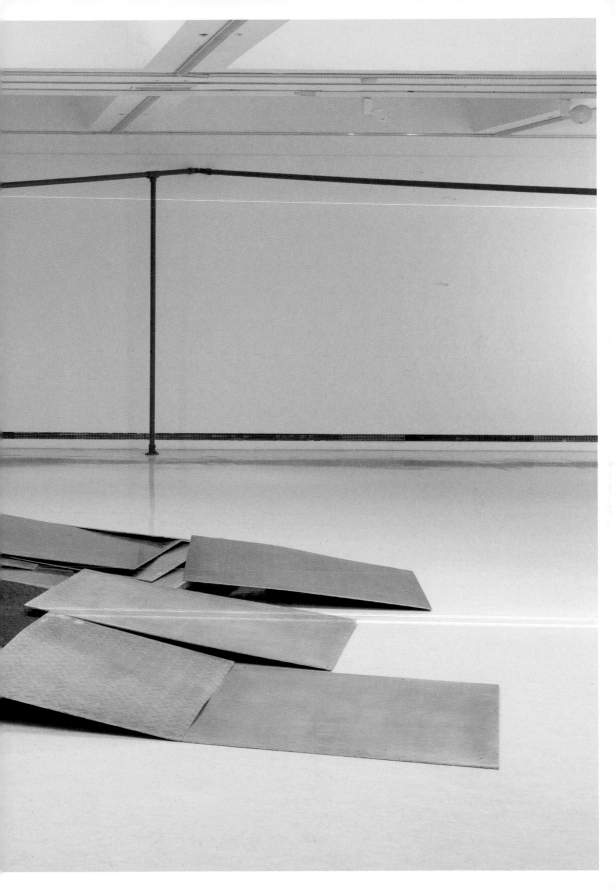

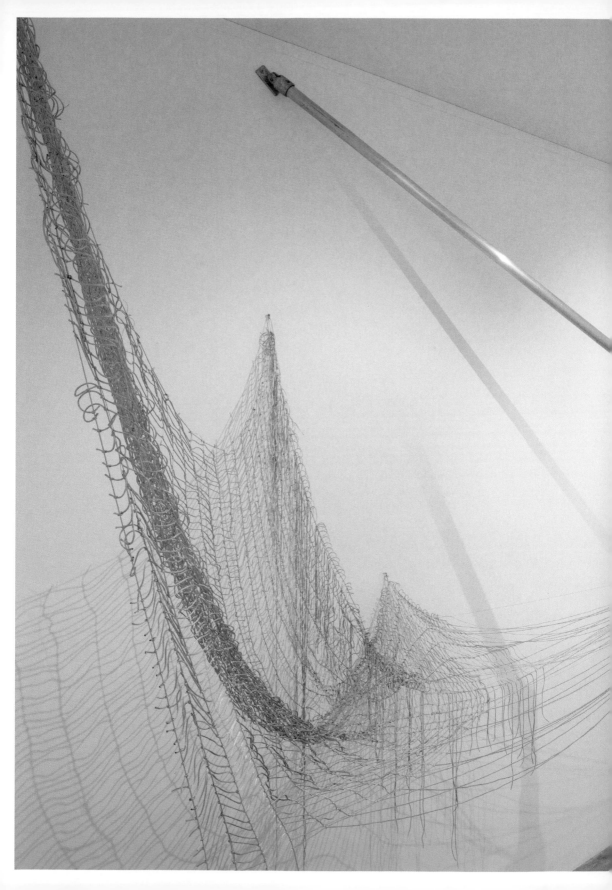

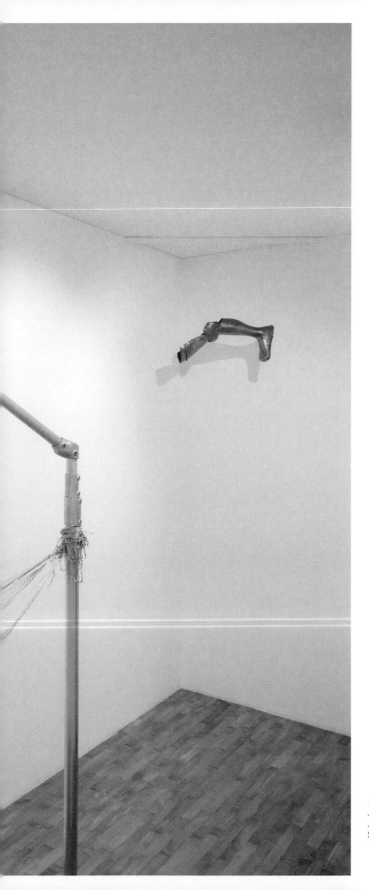

Winter Trees IV, 2016
Aluminium tubing, satin cord, dimensions variable
Leg defence, 1500s
Steel (from Glasgow Museums, RL Scott Collection)

259

JACQUELINE DONACHIE

Born Glasgow, 1969
Lives and works in Glasgow

EDUCATION

1987–91
Glasgow School of Art, BA (Hons) Fine Art,
Environmental Art

1995–96
Hunter College, New York, MFA (Fulbright
Scholarship)

2010–12
Honorary Research Fellow, School of Culture and
Creative Arts, University of Glasgow

2012– 16
Northumbria University, Newcastle Upon Tyne,
PhD Visual and Material Cultures

SELECTED SOLO EXHIBITIONS AND PROJECTS

2016
Deep in The Heart of Your Brain, Gallery of Modern
Art, Glasgow*

2015
South (Oslo), Aker Brygge, Oslo

2014
Mary and Elizabeth, Edinburgh Art Festival
Keep Up, Leamington Spa Art Gallery and Museum
Glasgow Slow Down, Glasgow 2014 Cultural
Programme of the XX Commonwealth Games
(with legacy commission, Glasgow Cross, Glasgow)
*New Weather Coming, GENERATION: 25 Years
of Contemporary Art in Scotland*, National Galleries
of Scotland

2013
Jacqueline Donachie/Glimmer, Patricia Fleming
Projects, Glasgow
Melbourne Slow Down, Desire Lines, Australian
Centre for Contemporary Art, Melbourne

2012
Contemporary Art Society New Acquisition,
Leamington Spa Art Gallery and Museum

2011
Temple of Jackie, Radar, Loughborough University
Arts

2010
Speedwork, Glasgow International, Bellahouston Park,
Glasgow

* exhibition catalogue

2009
Huntly Slow Down, Deveron Arts, Huntly,
Aberdeenshire

2006
Tomorrow Belongs to Me, Hunterian Museum,
Glasgow (with Prof. Darren G. Monckton)*

2004
Green Place, Whitworth Art Gallery, Manchester

2003
A Walk for Greville Verney, Compton Verney,
Warwickshire*

2002
Jacqueline Donachie, i-n-k, Copenhagen
Dear Wives, IASPIS Gallery, Stockholm
Three Pinkston Drive, FRAC Languedoc-Roussillon,
Montpelier*

2001
South, Spike Island, Bristol
The House of Fun, Hal, Antwerp
Edinburgh Society, Talbot Rice Gallery, Edinburgh*

2000
In the Arms of Strangers, City Art Gallery, Leeds

1999
Jacqueline Donachie, The Pineapple, Malmo
The Trees, The Book and The Disc, Visual Art Projects,
Glasgow for the Darnley estate*
Sword, The Jerwood Gallery, London

1997
Stars + Bars, Collective Gallery, Edinburgh

1996
Home Taping, Marian Goodman Gallery, New York
*Tour Bus E-18 (*part of *Sawn-Off* project), Norrtalje
Konsthall*

1995
Knoll Galleria, Budapest

1994
Part Edit, Tramway, Glasgow*

SELECTED GROUP EXHIBITIONS

2012
Going Viral, Glasgow Science Centre and Brick Lane
Gallery, London
Artists and Science, Weizmann Institute, Tel Aviv*

2010
The Land Between Us, Whitworth Art Gallery,
Manchester*

2008
Talkin' Loud and Saying Somethin', Gothenburg
Museum of Art*
Perspectives on Muscle Disease, Novas Gallery, London

2004
Designer Bodies, Stills Gallery, Edinburgh

2003
AIR 2003, Gallery at Glenfiddich, Dufftown*

2002
Travelogue, Whitworth Art Gallery, Manchester*
New: Recent acquisitions of contemporary British art,
Scottish National Gallery of Modern Art, Edinburgh

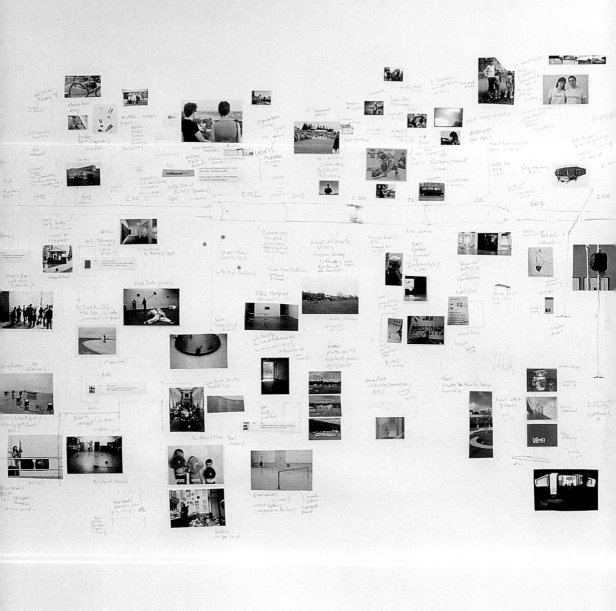

2001
Here and Now, Scottish Art 1990– 2001,
Dundee Contemporary Arts*
Circles, Center for Art and Media Technology,
Karlsruhe*

2000
International Selection, Salon de Montrouge, Paris
and Institute of Contemporary Art, Lisbon

1999
48 Hours, Tablet Gallery, London
In The Midst of Things, Bournville, Birmingham*
Freestate, art.tm, Inverness*

1998
Magic Carpet, Malmo Art Museum
Host, Tramway, Glasgow
Narrative Urge, Upsalla Konstmuseum

1997
Site and Sound, Site Gallery, Sheffield
Correspondences Scotland – Berlin, Martin
Gropius-Bau, Berlin and Scottish National Gallery
of Modern Art, Edinburgh*
Approach, CASCO, Utrecht

1996
Girls High, Old Fruitmarket, Glasgow*
Borland, Buchanan, Donachie, Gordon, Eigen + Art,
Berlin
Perfect Speed, USF Contemporary Art Museum,
Tampa, Florida*
Kilt ou Double, La Vigie, Nimes
Jack Tilton Gallery, New York (with Roderick
Buchanan)

1995
Maikäfer fleig, Bunker, Ehrehnfeld, Cologne

Ateliers du FRAC du Payes de la Loire,
St Nazaire
Karaoke, South London Gallery, London
Ideal Standard Summertime, Lisson Gallery,
London
Inside Out, Aldrich Museum of Contemporary
Art, Connecticut
Shift, De Appel, Amsterdam*
Make Believe, Royal College of Art, London*
Every Time I See You, Galleri Nicolai Wallner,
Malmo; Galleri Index, Stockholm

1989
Information, Paisley Museum and Art Galleries

RESIDENCIES AND AWARDS

2017
Freelands Award, The Fruitmarket Gallery,
Edinburgh

2016
Creative Scotland Artists' Bursaries Award,
Open Project Fund

2015
AHRC Anniversary Film Awards, BFI London
Winner, 'Best Doctoral Film since 1998'
Wellcome Trust Arts Award, with Glasgow
Museums

2014
Research residency, School of Sports Science,
Loughborough University / Radar

2012 – 15
AHRC Doctoral Award,
Northumbria University

2009–10
Residency, House for an Art Lover, Glasgow

2008
Marigold Foundation Award, Canada

2006–09
Lead artist, Centre for Health Science, Inverness

2005
Paul Hamlyn Award for the Visual Arts
Scottish Arts Council, artists award

2003–05
Wellcome Trust SciArt Production Award (with
Department of Life Sciences, University of Glasgow)

2003
Artist in Residence, Glenfiddich Distillery, Dufftown

2002
IASPIS Stockholm – International Artists Studio
Programme in Sweden
Copus – Connecting People to Science Award, with
the University of Glasgow
Wellcome Trust SciArt Research Award, with
Department of Life Sciences, University of Glasgow

2001
Henry Moore Sculpture Fellowship, Spike Island,
Bristol

BIBLIOGRAPHY

2016
*Deep in the Heart of Your Brain: Notes from an
Exhibition*, Susan Pacitti (ed.), Glasgow Museums
Jacqueline Donachie, *Illuminating Loss: the
capacity for artworks to shape research and care
in the field of genetics* (PhD thesis), University of
Northumbria, Newcastle upon Tyne
Moira Jeffrey, 'Jacqueline Donachie', *The Scotsman*,
28 May 2016
'2016 – How was it for you? #4: Jacqueline
Donachie, artist & Freelands Award winner',
a-n, 22 December 2016

2014
*GENERATION, 25 years of Contemporary Art
in Scotland*, Moira Jeffrey (ed.), National Galleries
of Scotland, Edinburgh

2013
Jo Vergunst and Anna Vermehren, 'The Art
of Slow Sociality: Movement, Aesthetics and
Shared Understanding', *Cambridge Anthropology*,
Volume 30, Issue 1, Spring 2012, pp.127–42 – also
appears as a chapter in *Sociality: New Directions*,
Nicholas J. Long, Henrietta L. Moore (eds),
Berghahn Books, New York, Oxford, pp.191–208
Moira Jeffrey, 'Jacqueline Donachie, Patricia
Fleming Projects, Glasgow', *The Herald*,
16 November 2013

2012
Intersections: Science in Contemporary Art (exh. cat.),
Weizmann Institute of Science, Tel Aviv
Desire Lines (exh. cat.), Australian Centre for
Contemporary Art, Southbank

2010
Nuno Sacramento and Claudia Zeiske,
*ARTocracy, Art, Informal Space, and Social
Consequence: A Curatorial Handbook in Practice*,
Jovis Verlag GmbH, Berlin
The Land Between Us: Place, Power and Dislocation
(exh. cat.), Whitworth Art Gallery, Manchester

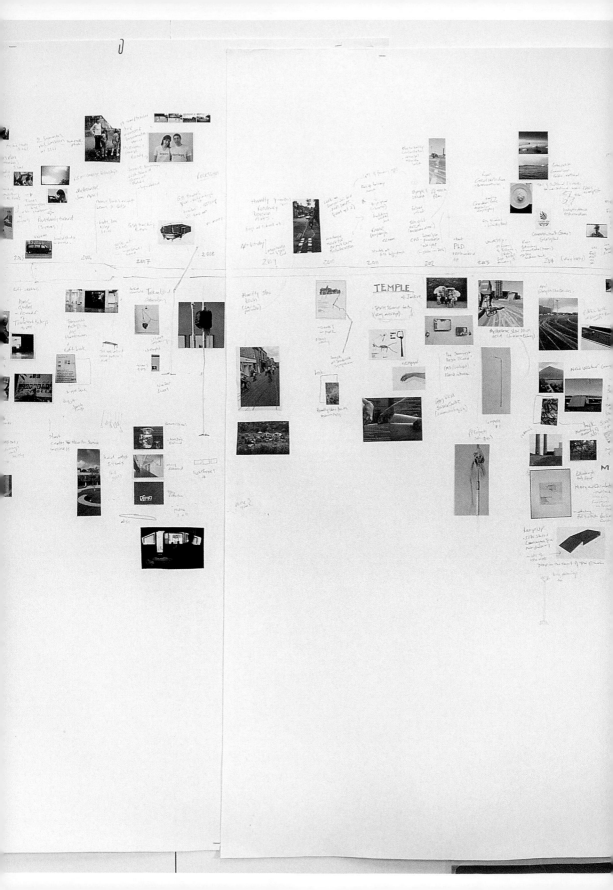

works with people

Sarah Lowndes, *Social Sculpture: The Rise of the Glasgow Art Scene*, Luath Press, Edinburgh

2009
Mika Hannula, 'Catch Me if You Can: Chances and Challenges of Artistic Research in Art and Research', *A Journal of Ideas, Contexts and Methods*, Volume 2, No. 2, Spring 2009

2008
Talkin' Loud and Sayin' Something: Four Perspectives of Artistic Research (exh. cat.), Mika Hannula (ed.), in *ArtMonitor: A Journal on Artistic Research, No.4*, University of Gothenburg, pp.36–57

2007
John Calcutt, 'The Doctor Will See You Now,' *MAP Magazine*, Issue 8, Winter 2007, pp.34–39

2006
Jacqueline Donachie and Prof. Darren G. Monckton, *Tomorrow Belongs to Me*, Hunterian Museum, University of Glasgow
Sam Stead, 'Bittersweet anticipation: the logistics of inheritance', *Art & Research: A Journal of Ideas, Contexts and Methods*, Volume 1. No. 1. Winter 2006/07

2005
Mika Hannula, Juha Suoranta, Tere Vadén, *Artistic Research – Theories, Methods and Practices*, Academy of Fine Arts, Helsinki, case study 2, pp.125–130

2004
Somewhere to Stand: Jacqueline Donachie Selected Projects 1994–2003; Talbot Rice Gallery, Edinburgh and FRAC Languedoc-Roussillon, Montpellier

2003
AIR 2003, Glenfiddich Distillery, Dufftown

2002
Travelogue Catalogue (exh. cat.), Whitworth Art Gallery, Manchester

2001
Here + Now, Scottish Art 1990–2001 (exh. cat.), Dundee Contemporary Arts, Dundee
Circles (exh. cat.), Center for Art and Media Technology, Karlsruhe

2000
Caroline Woodley, 'Sounds from the scene of the spectacle: Caroline Woodley on Jacqueline Donachie', *MAKE: The Magazine of Women's Art*, Issue 90, December 2000, pp.13–15

1999
In The Midst of Things (exh. cat.), Bournville, Birmingham

1997
'Pick of the Day: Stars and Bars by Jacqueline Donachie', *The Scotsman*, 19 August 1997
Suspended Points: No 1, Collective Gallery, Edinburgh
Correspondences Scotland (exh. cat.), Martin-Gropius-Bau, Berlin and National Galleries of Scotland, Edinburgh, 1997

1996
Girls High (exh. cat.), The Old Fruitmarket, Glasgow School of Art
Perfect Speed (exh. cat.), USF Contemporary Art Museum, Tampa
'Roderick Buchanan and Jacqueline Donachie, Jack Tilton Gallery', *Time Out New York*, Issue 43,

17–24 July 1996
Sawn-Off (exh. cat.), interview with Dan Graham
and Alexander Alberro

1995
Shift (exh. cat.), De Appel, Amsterdam
Make Believe (exh. cat.), Royal College of Art,
London

1994
New Art Scotland (exh. cat.), CCA Glasgow, 1994
'Jacqueline Donachie, Tramway, Glasgow,
Douglas Gordon', *Frieze*, Issue 18, Sept–Oct

ARTIST'S BOOKS

2014
New Weather Coming, National Galleries
of Scotland, Edinburgh and Glasgow Life
Edition of 6,000 copies

2010
Huntly Slow Down, Deveron Arts, Huntly
Edition of 1,000 copies

2002
DM, University of Glasgow
Edition of 1,500 copies, reprinted 2005, 2008

1999
Home Improvements, Tablet Gallery, London
Edition of 100 copies
Kenny's Head, Visual Art Projects, Glasgow
Edition of 1,500 copies

1997
3532 Miles, The Armpit Press, Glasgow
Edition of 1,000 copies

1995
Handwashing, FRAC Payes du la Loire, St Nazaire
Edition of 250 copies

1994
Part Edit, Tramway, Glasgow
Edition of 500 copies.

1992
The Last Occasion of Your Life, self-published
Edition of 10 copies

ACKNOWLEDGEMENTS

This book is published on the occasion
of the exhibition

JACQUELINE DONACHIE:
RIGHT HERE AMONG THEM

11 November 2017 – 11 February 2018
The Fruitmarket Gallery, Edinburgh

Winner of the inaugural Freelands Award

Published by The Fruitmarket Gallery,
45 Market Street, Edinburgh, EH1 1DF
Tel: +44 (0)131 225 2383, info@fruitmarket.co.uk
www.fruitmarket.co.uk

Edited by Fiona Bradley
Designed and typeset by Elizabeth McLean
Assisted by Susan Gladwin

ISBN 978-1-908612-48-9

© 2017 The Fruitmarket Gallery, the artists,
authors and photographers

cover: *Studio, 1995,* 2016
digital print on Hahnemühle Photo Rag
110 x 180cm (unframed). Courtesy of
Patricia Fleming Projects, Glasgow

Distributed by
Art Data, 12 Bell Industrial Estate
50 Cunnington Street, London W4 5HB
Tel: +44 (0)208 747 1061
www. artdata.co.uk

Jacqueline Donachie thanks
Alien and Daughter, Duncan Bain,
Phyllida Barlow, Fiona Bradley, Katie Bruce,
Roddy Buchanan, Archie, Duncan and James
Buchanan, Stella and Jim Buchanan, Melanie Cassoff,
Susan Craig, Alan Dimmick, Graeme Donachie,
Kathleen Donachie, Michelle Emery-Barker,
Juliana Engberg, Patricia Fleming and all at Patricia
Fleming Projects, Freelands Foundation, The
Fruitmarket Gallery, Glasgow Sculpture Studios,
Tom Harrup, Euan McLaren, Elizabeth McLean,
Neil McGuire, Eric Michael, Jamie Mitchell, Holger
Mohaupt, Elisabeth Murdoch, Steff Norwood, R + R
Fabrications, Kate V Robertson, Scottish Sculpture
Workshop (Eden Jolly and Uist Corrigan), Billy
Teasdale, Deniz Uster, Henry Ward, Sam Woods.

And everyone who has danced, dined, walked, spoken,
sung and cycled along the way.

Writing credits
All texts © Jacqueline Donachie unless stated.
p.26: Extract from *Part Edit*, 1994, Tramway,
Glasgow
p.33: Extract from 'Bars 1995–2001', *Somewhere
to Stand: Jacqueline Donachie Selected Projects
1994–2003*, Talbot Rice Gallery, Edinburgh and
FRAC Languedoc-Roussillon, Montpellier
p.44: Extract from *How Late it Was, How Late*, James
Kelman, Minerva, London, 1995 © James Kelman
p.52: Extract from *3532 Miles*, 1997, The Armpit Press,
Glasgow
p.64: Extract from *Kenny's Head*, 1999, Visual Art
Projects, Glasgow
p.72: Text from leaflet that accompanied the first
installation of the work at Leeds City Art Gallery,
2001
p.84: Text from poster work MORE MORE
MORE, 2001, HAL, Antwerp
p.109: Conversation between the artist and Henry
VIII's Wives, a Scots/Scandinavian artists' collective
founded in Glasgow in the 1990s. Extract from
'Dear Wives', IASPIS, Sweden, November 2002
p.112: Extract from *DM*, 2002, University of Glasgow
p.158: Extract from *Huntly Slow Down*, 2010,
Deveron Arts, Huntly
p.187: Text from leaflet that accompanied the project,
Glasgow International, 2010
p.196: 'I Steal Sun', *Going Viral* exhibition label, 2012
pp.208; 222; 228; 238; 243: Extract from *Jacqueline
Donachie, Illuminating Loss: the capacity for artworks
to shape research and care in the field of genetics* (PhD
thesis), University
of Northumbria, Newcastle 2016
p.212: Preparatory notes, *Mary and Elizabeth*, 2014

Photographers credits
Stuart Armitt, Ruth Clark, Alan Dimmick,
Emlyn Firth, Marc Ginot, Kate Hannay,

Jan Kempenaers, Holger Mohaupt, Jen Moore,
Des O'Sullivan, Tony Richards, Lisette Smits,
Simon Starling, Emma Sullivan, Ewen Wetherspoon,
Ross Williams

The Fruitmarket Gallery is a company limited by
guarantee, registered in Scotland No. 87888 and
registered as a Scottish Charity No. SC 005576.

VAT No. 398 2504 21. Registered Office:
45 Market Street, Edinburgh, EH1 1DF

The Fruitmarket Gallery programmes exhibitions
with the best Scottish and International artists
and enriches these with a wide variety of cultural
and educational events. We are committed to
making contemporary art accessible without under-
estimating audiences or compromising art or the
ideas it enacts.

We create a welcoming space for people to think
with art in ways that are meaningful to them
– for free.

Our exhibitions, publications and events aim
to show thinking happening, to demonstrate that
art is a creative, active and generous cultural force,
to resonate with visitors and to create an enriching,
challenging context for an audience's own ideas.

We believe that engaging with art in this way is enjoyable, leads to an improved quality of life, and revitalises our understanding of ourselves as individuals and as part of society.

Publishing is an intrinsic part of The Fruitmarket Gallery's creative programme. Books are conceived as part of the exhibition-making process, extending the reach and life of each exhibition and offering artists and curators a second space to present their work.

Commissioning Patrons
The Thomas Family
Nicky Wilson

Programme Patrons
Sophie Crichton Stuart
Alistair and Susan Duff
Barry Rosen

Patrons
Martin Adam and William Zachs
Nan and Robin Arnott, Christina Chaplin
Elizabeth Cowling, Sarah Donaldson, Ray Entwistle,
Catherine Holden, Florence and Richard Ingleby,
Callum Innes, Robin Jack, Werner Keschner and
Catherine Muirden, Iain McFadden,
Diana McMicking, Ruth Rattenbury,
Peter and Susie Stevenson, Silvy Weatherall,
Robert Wilson and those who wish to remain
anonymous